Great TRAVEL PHOTOGRAPHY

W9-AEZ-059

A12901 349879

CLIFF AND NANCY HOLLENBECK

I.C.C. LIBRARY

PHOTO-IMAGING
Amherst Media's
SERIES

AMHERST MEDIA, INC. ■ AMHERST, NEW YORK

TR
790
.H65
1996

About the Authors

Cliff and Nancy Hollenbeck are one of the travel industry's leading photography and film making teams. Their images are used by major airlines, cruise lines, advertising agencies, national magazines, book publishers, and tourism associations.

Cliff has twice been named *"Travel Photographer of the Year"* by the Society of American Travel Writers. He has participated in several *Day In The Life* book projects. Together, the Hollenbecks have authored eight books on photography, travel, and business. Their most recent pictorial book, *Mexico*, includes an introduction by novelist James A. Michener, and an essay by noted writer Richard Pietschmann.

The Hollenbeck's film company, Hot Shot Productions, has received gold medals at both the International Film Festivals of Chicago and New York. The film company specializes in producing commercials and sales videos on travel subjects similar to to their still photography.

Right: *A young Hawaiian woman rides a Tropical Killer Whale. A shutter speed of 1/500th of a second was needed to make this sharp image. Sea Life Park, Honolulu, Hawaii. Made with 180mm lens.*

Copyright © 1996 by Cliff and Nancy Hollenbeck

All rights reserved.

Published by:
Amherst Media Inc.
P.O Box 586
Amherst, NY 14226
Fax: 716-874-4508

Publisher: Craig Alesse
Editor/Designer: Richard Lynch
Associate Editor: Frances J. Hagen
Contributing Editor: Daniel Paul Schwartz, J.D., Ph.D.
Photos by: Cliff and Nancy Hollenbeck
Equipment photos courtesy of Helix Camera and Video, Chicago, Illinois.

ISBN: 0-936262-48-6
Library of Congress Catalog Card Number: 96-84433

No part of this publication may be reproduced, stored, or transmitted in any form or by any means, electronic, mechanical, photocopied, recorded, or otherwise, without prior written consent from the publisher.

Notice of disclaimer: The information contained in this book is based on the authors' experience and opinions. The author and publisher will not be held liable for the use or misuse of the information in this book.

Printed in the United States of America
10 9 8 7 6 5 4 3 2 1

TABLE OF CONTENTS

INTRODUCTION

Imagine taking a gondola ride along the Grand Canal in Venice; walking among the temples and gardens of Bangkok's magnificent Grand Palace; SCUBA diving in the turquoise waters that brush against St. John's sugar white beaches in the Virgin Islands; shopping in the colorful bazaar of Istanbul, a city that touches both Europe and Asia, or hiking along the emerald green cliffs of Kauai in the Hawaiian Islands. Sound beautiful? They are beautiful — beyond the accurate description of words.

The World of Travel Photography

"THE WORLD IS A BEAUTIFUL PLACE, JUST WAITING FOR YOU TO SEE AND PHOTOGRAPH..."

The world is a beautiful place, just waiting for you to see and photograph colorful cultures, exotic cities, action adventures, and scenic vistas beyond belief. This is the world of travel photography. It's a world that takes on a whole new look when viewed through the lens of a camera. Simple things like the light at dusk, sunrise filtering through a stained glass window, or a lone palm tree rising out of the mist in a distant jungle, somehow become more important and memorable when seen through a photographer's eye.

Almost everyone that travels also takes pictures, thousands of pictures. Photography has come a long way since George Eastman began selling his amateur Kodak Number One Camera in 1888. Worldwide, we estimate that more than 25 billion photos are taken each year by some 300 million cameras. It's the easiest, and most prolific art, industry, and form of communication, and all you have to do is aim and push a button. Snap and you're a photographer, storyteller, and communicator who can be understood by all the people of the world, at a single glance.

Sadly, most of these photographs are simple snapshots recording family events and travels. Not that snapshots are all that bad, some of these pictures are very nice, but generally, you're tired of looking at them long before your neighbor has finished showing off the hundreds of prints from his recent vacation. With a little advance planning, some interesting ideas, the right film and camera, your neighbors will be impressed by the photography from your next trip, especially if you've followed the suggestions in this book.

"GREAT TRAVEL PHOTOS ARE PLANNED AND MADE, NOT TAKEN."

Start with a Review of the Basics

Great travel photos are planned and made, not taken. If you want to make them, a grasp of basic photography is important. Before packing up your cameras and heading out for a month of trekking around villages in the High Himalayas, take a few minutes to review and renew your photographic abilities. There are enough things that can go wrong during a major trip without having to worry about something that is easily covered before leaving home.

The best place to start a basic review is by reading your photographic equipment manuals. Make sure you know how everything works, and spend a little time actually working everything. Simple things like setting film speeds and exposure ranges, or attaching accessories and changing lenses, should be second nature. With the new electronic cameras, it's also a good idea to practice making checks and corrections for malfunctions.

When you're comfortable with the equipment, spend a weekend shooting a few test rolls of film near home. Shoot with every piece of equipment you anticipate taking on a future trip. Try different lighting conditions: inside, in the shade, in the sun, at sunset, and so on. Shoot close, shoot from a distance, shoot wide, shoot tight with a telephoto. Shoot people, shoot scenics, shoot animals, and shoot objects. In other words, get comfortable with your photographic ability. A good place to accomplish this is at a local zoo, theme park, or parade.

This simple review will also tell you what equipment works well, and how much a bag of gear weights at the end of a long day. It will also show how competent you are with the equipment, and what equipment needs to be replaced and purchased.

Potato farmers selling their crop at a local weekend market. Khabarovsk, Siberia, Russia. Made with 180mm lens.

Opportunities and Challenges

Travelers with cameras face a multitude of opportunities and challenges when roaming around in search of great photographs and interesting travels. By reading this book, we know you're ready to enter into, or improve, your world of travel and photography.

By writing this book, we've tried to simplify the complicated processes of world travel, while combining them with the artistic and scientific sides of making quality photography. We've done everything suggested in these pages hundreds of times. Our suggestions and ideas have been tried and proven, through trial and error, over the past 20 years. That doesn't mean you can't improve on our ideas, find mistakes in this book, or learn something we've never imagined. Experimentation is one of the joys of exploring with a camera.

Throughout this book, we recommend visiting professional photographic stores, using custom processing labs, and testing everything possible before traveling. We know there are lower cost places to shop, and that constant testing can be expensive. We have learned over the years that professional suppliers are also great teachers, as are constant trial and error tests. You'll get what you pay for in both cases.

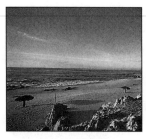

Sunrise, about 6am, along the beach at Palmilla Resort. San Jose del Cabo, Baja, Mexico. Made with 18mm lens.

If you discover mistakes, or have ideas which will improve on future editions of this book, please drop us a note and we'll consider making changes. No commercial organization pays us, gives us equipment or discounts, or in any other way determines the recommendations in this book.

And, just because we recommend a particular item doesn't mean a similar product from another company won't work as well for you. Our suggestions are starting places from which your own style and system should evolve.

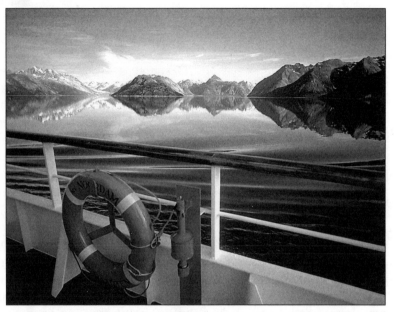

Perspective and depth are added by shooting across Holland America cruise ship railing and life ring. Glacier Bay, Southeast, Alaska. Made with 24mm lens.

Get Lost!

After reading this book and embarking on your next full-fledged travel photo trip, we suggest you get lost! That's right, get off the bus and walk around, drive the rent-a-car on some uncharted roads and get yourself lost. Stop and talk with people. Ask directions. Ask if you can take some pictures. Ask if they know about any interesting subjects for your camera. By getting lost, you'll actually find lots of interesting things to see with your camera — most of which aren't found in the typical guide books.

We wish you safe travels, good luck, and good photo shooting along the way.

Chapter 1

CAMERAS & EQUIPMENT

Nikon N90s SLR 35mm Camera

CAMERA SYSTEM

A related system of camera, lenses, flash, and accessories that are all produced by the same manufacturer.

Systems generally guarantee that everything works together. This is important with completely automatic cameras.

Making pictures while traveling away from the immediate area of your home requires cameras and equipment that are lightweight, easy to operate, and dependable. The better the quality of your equipment, the better your photos will turn out — technically.

While the quality of equipment is important, keep in mind that cameras only record the images that you, the photographer, see. The better your ability to see a picture, the better your photos will turn out — creatively.

Equipment Systems

We suggest buying into a name brand "*camera system.*" Using a camera system means one-stop shopping for all your normal equipment needs. A system means everything is compatible and probably covered by a single users handbook. Selecting a name brand of equipment usually means world-wide availability for parts, replacements, and repairs. Manufacturers of the better systems provide leading edge research, a wide variety of models, and many different products from which to chose. They also provide informative seminars, workshops, publications, and promotional items made with their equipment.

Photographic stores, that cater to professionals, generally carry several different leading brands of equipment systems. We've used the Nikon system for 20 years. The system has stood up to several thousand rolls of film each year, often shot in climates not hospitable to cameras. There isn't a photo situation that can't be covered with Nikon equipment. Canon, Minolta, Pentax, and Olympus also make excellent professional systems. We suggest visiting a professional photography store and taking a look at several systems. You might rent one for a weekend before making a decision.

Cameras for Travel

There are several types of cameras available. We recommend the Single Lens Reflex (SLR), auto or manual exposure and focus, 35mm camera for travel photography. Most of the information in this book is based on the 35mm SLR camera and its related equipment system. Of

The basic travel photographers system. Includes SLR 35mm camera, wide-angle lens, mid-range, and telephoto zoom lenses.

"ALWAYS DOUBLE CHECK THE AUTO SETTING FEATURE..."

Photographer of tourists, with his homemade instant camera. First he makes a paper negative, which is copied into B&W prints. At the Acropolis, Athens, Greece. Made with 85mm lens.

course there are some very good "point and shoot", range finder focus, and professional large format cameras available. If you are interested in these other cameras, compare them to the SLR and make your own decision as to which is best for your travel needs.

The SLR 35mm camera lets you see, focus, and shoot through the lens just as the camera does. This eliminates a lot of guessing about what the picture will look like. Having the choice of auto or manual, for exposure and focus, allows you to test and use whichever system is best for your style, situations, and needs. Most of the name brands offer automatic cameras with manual override in all of their camera models.

Auto Focus & Exposure

The automatic focus and exposure systems are great for casual walk-around shooting. They're excellent for subjects that move around and lighting that is constantly changing. Shooting in the auto modes allows you to concentrate on the subject and picture making, rather than on the equipment. Today's manual cameras are really automatic when compared with models of a few years ago. They are mainly override systems which can be very useful in some situations, such as against a sunset. Your camera manual, and a little testing, will help you decide when it's best to override the automatic systems.

Auto ISO Setting

Film ISO speeds are automatically set on many cameras. Always double check to see that this auto setting feature is, indeed, doing the job. You must also manually override this system when shooting at a different ISO than the film manufacturer intended.

Auto Film Winders

Many of today's SLR cameras automatically advance the film after an exposure has been made. This allows about two shots a second to be made without pulling at the camera to make a manual film advance. Auto advance is also a must for "left-eye" shooters because most manual advance levers jab the right eye of these people.

If you shoot very fast moving subjects, such as athletes, a motor drive attachment can be added to the top professional models of most cameras. These drives range from three to ten exposures per second, which can help capture subjects moving at high speeds. Keep in mind that at 10 frames per second you can burn through a roll of 36 exposure film in less than four seconds.

Specialty Cameras & Equipment

There is some interesting specialty equipment on the market for underwater, aerial, close-up, ultra wide-angle, unusual weather, and rough handling conditions. Most of this special use equipment is expensive, heavy, difficult to operate, and not needed for general travel shooting. Some of these special travel conditions, and how to shoot them, are covered in a separate chapter.

Computer imaging has brought out a great deal of research into cameras that record digitally. Nikon and Canon are offering versions of digital cameras with Kodak recording systems. For the most part, these are based on their 35mm SLR's, looking and operating similarly to those film recording cameras. The current digital cameras are much larger, heavier, and as you would expect with new technology, more expensive. However, it won't be long until most general use cameras record in some magnetic system, which allows TV screen viewing as well as photographic type print output. If you have an interest in computer imaging, it's an exciting time to get involved with digital cameras.

Lenses for Travel

Selecting the right lenses for travel photography is much the same, and just as important, as selecting the right camera. Nikon offers about one hundred different lenses from which to choose for their 35mm cameras. Looking at all of these lenses in their sales catalogs can make the decision seem impossible. It really isn't. You can cover just about any normal travel subject with two simple zoom lenses.

Nikon 35-70mm Zoom lens

Your "always on the camera" lens should be a semi wide to semi telephoto zoom lens, in the range of 35mm to 135mm, which will cover most general shooting subjects and distances. With this zoom lens you can cover small groups, full length people, semi close-ups, and faces. In other words, just about any subject you can approach with a camera.

Sailboats in sunsets, sports, animals, and anything difficult to approach, can easily be covered with a medium telephoto zoom lens, in the range of 80mm to 200mm. This lens is excellent for making tighter shots of subjects that are hard to approach, say in a public market, or from a viewing stand.

Many professional travel photographers carry two camera bodies, with one of these zooms lenses mounted on each, allowing them to cover just about any subject they come across. This is a nice idea because it also provides an extra camera should one break down. Most zoom lenses have close-up capabilities for flowers, sea shells, coins, and the like. Make sure any lens you purchase is also compatible with the camera's through the lens exposure and electronic flash metering.

Additional Lens Coverage

We also suggest a good wide-angle lens to make nice scenics, sunsets, and bigger group shots. A 20mm or 28mm, is an excellent addition to your lens set. If you want to make an occasional longer telephoto shot, but don't want the added expense of those lenses, try an extender (also called a doubler). Most lens makers have extenders that will double the focal length for many of their lenses. Your 80mm to 200mm zoom can become a 160mm to 400mm lens with the addition of this accessory. We suggest using this setup in bright daylight, mounted on a tripod if possible, as extenders also cut the amount of light coming through your lens.

Nikon 80-200mm Zoom lens

"A TRIPOD IS A MUST WHEN SHOOTING WITH ANY LENS OVER 200MM."

If you're interested in shooting birds, wildlife, and other distant subjects, telephoto lenses beyond 500mm are necessary. If this is a casual interest, we suggest a good 500mm or 1000mm mirror-reflex telephoto lens. Reflex lenses are substantially shorter, lighter in weight, and less expensive, when compared to the long focus standard telephoto lenses. A tripod is a must when shooting with any lens over 200mm.

Fast & Slow Lenses

All lenses have a maximum aperture opening which is listed behind the focal length in catalogs and manuals. For example, the Nikkor zoom 80-200 f/2.8 is a lens that can be opened to f/2.8, and is considered a "fast" zoom lens. It allows substantially more light to reach the film when opened to it's maxim aperture of f/2.8, than the Nikkor 80-200 f/4.5 lens does when opened to it's maximum opening of f/4.5. Manufacturers generally offer two or more different maximum lens openings, or speeds, for their popular focal length lenses.

What all this really means is the faster lenses allow several things: easier focus, higher shutter speeds for moving subjects; better depth of focus, or a sharper picture when set in their mid f/stop range (generally about f/8 and f/11), and a wider range of shooting possibilities in low natural light. The faster a lens, the more expensive, larger, and heavier it is. Travel photographers can get by with a mid-range lenses between f/3.5 and f/2.8. Most pros use the f/2.8 and faster lenses.

Super Lenses

Nikon 400 f/2.8 Super Lens

For the serious professional, and wealthy amateur, there are also some interesting super lenses available. These lenses can reach the stars, photograph things so small the human eye can't see them, shoot inside the human body, and so on. You won't find these lenses at variety stores or one hour photo labs. Professional stores have them available, often only by special order. The cost is also high. For example, those huge lenses you see along the sidelines of sporting events can cost between $5,000 and $10,000 each. You won't see many travel photographers willing to spend this kind of money, or crazy enough to carry heavy lenses.

Chapter 2

PHOTOGRAPHY ACCESSORIES

PHOTOGRAPHY ACCESSORIES:

- Flash
- Batteries
- Tripod
- Filters
- Cases
- Cleaning and Repair Kit

There are a few additional basic photographic accessories that are important for travel photography. All of these items should be sampled and tested to see if they meet your location and photographic needs.

Flash

A small automatic exposure flash unit, sometimes called a strobe light, is one of the best ways to make great travel photos, especially when there is no source of light available for natural shooting. We also recommend using a flash in the bright sun to fill the shadows on faces, or just to add a little contrast in flat and overcast daylight. What a small flash can't do is light up an entire stadium or restaurant.

A good traveler's flash is smaller than your tele-zoom lens, mounts directly on your camera's "hot shoe," and automatically sets exposure through the camera. If your flash and camera are of the same make, through the lens flash exposure metering should be possible.

Professional travel photographers almost always shoot their outside daylight people shots with a little flash fill. The only exception to this rule is in early morning and late afternoon light, when their subjects' shadow are twice as long as their height. Flash units in the better camera systems figure out their own flash fill exposure and let you "tweak" the results. Test a few daylight shots with and without flash fill to reach your own conclusions as to what works best.

Professionals also carry a second matching flash unit. This acts as a backup unit, and can be used as a remote flash "slave unit" too. A simple electronic eye or remote attaching cord allows the second unit to be placed beside or behind interior and night subjects. Multi-flash photography separates subjects from backgrounds, adds contrast, and eliminates shadows caused by the main flash unit.

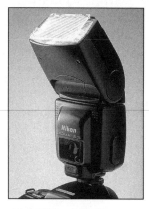

The Nikon hot shoe camera mounted electronic flash provides automatic through-the-lens exposures and fill light when used with their camera systems.

Batteries

When considering the purchase of equipment, try to have everything operate on the same size batteries. Quite a few camera systems and flash units operate on pen light batteries which are generally available around the world. Some of the higher tech electronic cameras need

special and expensive batteries. Check this out in advance of travel as well as purchase.

Always carry several extra sets of batteries which have been purchased from a known source. Even though batteries are available throughout the world, who knows how long a set has been on the shelf in a small village? Stick with name brand and quantity battery purchases, perhaps from a local bulk or wholesale house.

If your electronic camera, or other equipment, fails to operate, it's almost always due to the batteries. If things don't operate after you've changed batteries, change them again before taking anything apart. Even the best batteries can fail after improper storage.

Tripod

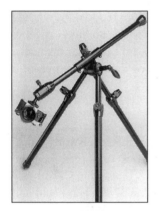

Exciting night, dusk and natural light interior photos can be made with the aid of a good tripod. This is a Benbo tripod.

There are a multitude of exciting night, dusk, and natural light interior photos to be made with the aid of a good tripod. The only problem with good tripods is they are almost always large and heavy. A tiny ball-point-pen-sized tripod which opens up to six foot isn't steady enough to hold a handkerchief, let alone a camera.

We suggest a sturdy "journalist" type tripod, made of aluminum, which opens to about five feet and folds down to about two feet. It also fits in your traveling case. A simple "quick release" system will allow you to mount quickly in the dark. Check out several tripods before making a decision.

We also recommend a small table-top tripod which can close down to about six inches, and a camera clamp. These devices allow you to set up or hook cameras to cars, tables, trees, or fences, and shoot steady in low light. This will make much sharper photos than hand holding during slow exposures.

Use a tripod with any lens over 200mm, and for any exposure slower than 1/60th of a second. Use a 12" or longer cable, or electronic shutter release anytime a tripod or other mounting device is needed. This will prevent bumping into the camera when starting and stopping a long exposure.

Filters

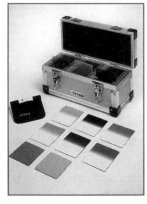

The professional line of Tiffen glass filters.

Some photographers prefer to record a scene exactly as nature presents it, often waiting great periods of time for nature to become perfect. Less patient photographers often "correct" a scene with correction filters. Still others "enhance" a scene with a variety of creative filters.

There are thousands of different correction, enhancement, and creative filters on the market. Their use, cost, and result is almost as varied. This is an area in which you need to compare several examples and make your own tests before going too far.

First off, we think that every lens you own should be protected by a clear Skylight or slight Warming (81A) filter. The cost of these filters is about 1/100th of replacing a broken front lens element which has been hit by a rock, dropped, or sprayed by salt water. These filters can be cleaned with a cloth, shirt, or napkin; your front lens element can't.

Carry at least one extra filter for each size lens you own. To help you get started in building a working set of filters, we've listed some that are most common in travel photography:

Polarizer (gray)

This is one of the most popular filters. It's really a polarizing screen with scenic photographers. It enhances a blue sky, making it darker against white clouds; it also makes green vegetation jump off the final photos.

A good polarizer also reduces or eliminates reflections from non-metallic surfaces such as water. In order for one to work well, keep the sun beside or behind your shooting position.

Read the instructions carefully with this filter. Such filters must be adjusted for each shot. Never use a polarizer to shoot people's faces because it does nothing for flesh tones. A polarizer reduces the amount of light reaching the film by at least one-half, which an auto exposure camera can adjust. Otherwise, you must make the change manually. The same company that makes your lens should be the source of a polarizer — it will be expensive.

Warming Filters (81A-81B-81C-81D-81EF)

These filters are actually for correcting scenes, such as early morning mist and mountain light, returning them back to normal daylight. We like to use them to warm normal daylight scenes a little, especially faces and sunsets. These filters are slightly yellow-red in color, and add that feeling to any scene.

The A filter is mild up to the EF which is stronger in its color. We use the 81A full-time on all our lenses for a slight warming, as well as for lens protection.

Tungsten to Daylight Filter (85A)

This correction filter (slightly red) is normally used when shooting tungsten film outside in daylight. Travel photographers like to use it as a strong warming filter when the sun is at high noon. It adds a nice warm tropical look to any scene, including people, especially people with very white faces.

Light Correcting Filters

There are also other filters that allow you to shoot normal daylight film under fluorescent light (FLD or CC-30-M); tungsten light (85); underwater (CC-30-R), and other sources of non-daylight illumination. If you plan to shoot under these conditions, we suggest first trying to use an electronic flash which is daylight in color, before using a correction filter.

The better color printing labs have the ability to correct, to some extent, some of these non-daylight problems when making custom prints. This is something to discuss with the lab in advance. We suggest making several shots, using first the normal lens covering filter,

A VARIETY OF FILTERS TO CHOOSE FROM:

- **Polarizer**
- **Warming**
- **Tungsten to Daylight**
- **Light Correcting**
- **Graduated**
- **Creative**

followed with exposures using the best filter correction you think is needed for the situation. The more you travel and shoot, the easier it will be to see what is needed to make corrections.

Graduated Filters

There are about 30 different graduated filters, that range through graduated colors all the way to clear. This allows you to shoot a beach at sunset using a graduated yellow or red filter to add color to the sunset but not the beach.

Not all sunsets are created alike and this is a very good way to enhance the ones that nature forgot to make golden. Colors range from mauve and magenta, which enhances an evening sky over water, or a city scape at night, to blue graduated, which adds color to a daylight sky at high noon.

Graduated filters are available to make a redder sunset, a greener field , or a more golden beach. You can also reduce the brightness of a snow-covered mountain with a graduated neutral density filter.

Creative Filters

Creative filters can multiply a single image into two, four, six or a dozen or more images. They can create stars, rainbows, fog, mist, and a host of other interesting illusions and distortions.

While they come in several brands, and under as many different names, we suggest looking through the filter guides before making a purchase. Use these attachments to experiment with a subject after making a few normal shots.

Filter Guide

The Cokin Creative Filter Company produces an excellent field guide to their extensive line of filters. It has more than 500 examples of how-to, before and after, and changes that can be made with their filters. This guide should be the starting place for building any filter kit.

Lens Attachments

"EVERY LENS SHOULD HAVE A SUN SHADE..."

Every lens should have a sun shade that adds to the protection provided by a Skylight or 81A filter. The sun shade is important to use with wide-angle lenses which refract the sun, and most subjects that are lit from the side. Some telephoto lenses, and longer zoom combinations, have built in shades.

Most filters and creative attachments can be used with the sunshade. Always look through your lens with the f/stop set at the smallest number (usually f/2.8 or f/1.4). If the corners are dark, you need to remove the sunshade in order to use the attachment.

Lens caps are for storing lenses at home, or for protection when packed during travel.

If you need added protection for your lenses during travel, use a soft pouch. When you're in a location, lens caps are always in the way at the wrong time, usually when you need to make a fast shot.

Filter Quality & Cost

Some photographers believe in using only the finest ground glass filters and lens attachments which can cost between $50 and $200 each. Other photographers point out that very sharp images have been made when shooting through screen doors, baseball chain link fences, dirty airplane windows, and the like. We suggest that something in between is probably the real answer.

"Screw in" filters and attachments should probably be made of glass and limited to the Polarizer and Warming (81A or Skylight) filter that stays on the lens. Other filters should be 4x4 or 5x5 (inches), and made of the new high tech plastic or resin, such as those available from Cokin. Always get filters that are larger than the width of your biggest lens so they can be moved about freely on any of your lenses. They require an inexpensive adapter.

Camera & Travel Cases

A good quality camera bag is as important as any other single item for the travel photographer. In addition to carrying your shooting camera and equipment, it will carry repair kits, batteries, money, maps, flashlight, rain jacket, sun glasses, notebooks, film, and everything else you need during the shooting day. There are hundreds of well designed cases, that are solid, lightweight, and easy to use. Better camera stores will have an excellent selection, but don't buy until you've looked at the camping, fishing, hiking, and related cases available in recreational outlets. A good carrying case shouldn't have many metal parts to scrape equipment. It will be water resistant when closed, well-padded inside and out, and have several compartments to prevent equipment from banging into other equipment. Velcro fasteners are better than zippers or metal snaps.

Resist the temptation to buy a huge carry everything camera case. At the end of a long day of walking and making pictures, it will seem to weight two hundred pounds and rub your shoulders raw. A medium to smaller case, which holds only what you need to make pictures, and fits under an airplane seat, is best. Two smaller cases, one for you and one for your friend or spouse, are also better than a single large heavy case. Some cases have handy switchable straps that turn them into back-packs.

Working photographers like to use a photo or fishing vest when shooting. Vests should be made of lightweight material, large enough to wear over a sweater or jacket, and have two or three large and several small pockets that can be securely closed. The only drawback with vests is that cameras are too large for a pocket. Otherwise, they are very nice for quickly changing film and lenses.

Traveling Cases

Most pros carry so much equipment, with back ups, film, and clothing, they can't possibly hand carry all of it on an airplane. We generally

"A GOOD CARRYING CASE SHOULDN'T HAVE MANY METAL PARTS..."

Travel photographers need a variety of equipment cases. Hard aluminum shipping cases make sure equipment arrives safely, when checked as baggage. Soft over-the-shoulder cases are great for shooting days.

use double thick aluminum shipping cases which padlock and can be wired together in our room when we're away. A marine parts, or sail boat company, can provide plastic covered steel cables which are used to secure masts. A ten footer should be long enough to loop between cases, locks, and something in your hotel room.

Make a stencil of your name, address, and phone number. Such stencils are available at your local stamp making shop. Spray this information several places inside and outside of your traveling cases. Use a bright color which makes the case easy to spot on a baggage carousel, or on somebody else's luggage cart.

Cleaning and Repair Kit

A small cleaning and repair kit will probably save you a great deal of time on location. Carry the following items in a small zip-lock plastic bag: Lens cleaner, lens cleaning tissue, lens brush, jeweler's screw driver kit, small Swiss Army Officer's knife (a woodsman model with scissors, tweezers, and cork screw), waterproof flashlight (two pen light batteries), and a soft cotton dish-drying rag.

Additional Accessories

There are a number of additional items which don't fall under the heading of photo equipment that are important to travelers. We've provided a complete series of checklists under *Travel Planning* in Chapter 4, covering many of these items.

Buying Equipment

Because there are so many choices in cameras and lenses, and everyone has a different eye and style of shooting, don't buy anything without looking first. Visit your local professional photo store and compare a variety of equipment. We highly recommend testing equipment, through the store's rental department, before buying anything. Renting is also an excellent way to use the expensive professional equipment on a now-and-then basis.

We know that professional photo stores don't sell equipment as cheap as some discount stores or catalog outlets. On the other hand, these lower priced places don't have experienced sales people, don't allow advance testing, and are not nice about returns. Professional stores cater to the high demand for service and quality equipment that pros require. They also offer the opportunity to see and test equipment in advance of any purchase. If these things aren't as important to you, there are some great deals through the mail order stores advertising in photo magazines.

"PROFESSIONAL STORES CATER TO THE HIGH DEMAND FOR SERVICE AND QUALITY..."

Chapter 3

FILMS, PROCESSING & COMPUTERS

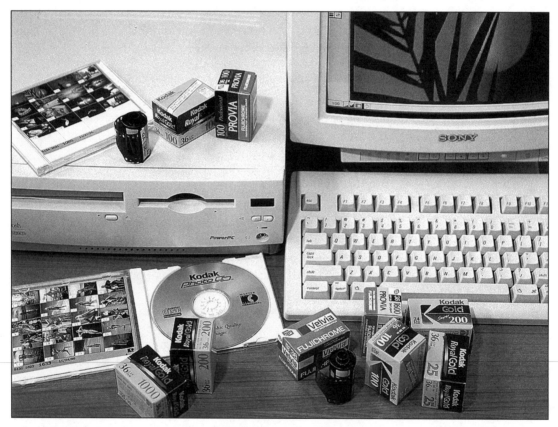

Photographers have a multitude of different film and after exposure options. No matter what your choice, make lots of tests before heading out on an adventure with a bag full of film.

The film, processing, printing, and other materials you select and use will determine the look and results of your photographic efforts. The more time and testing you put into these materials, the better your results will be. It's that simple.

"FILM IS THE LEAST EXPENSIVE, BUT MOST IMPORTANT ITEM..."

Films For Travel Subjects

Film is the least expensive, but most important item in the travel photographer's bag. We know you can't make a photo without a camera and lens, but the right film for the right situation will enhance your results better than the best camera equipment money can buy.

There are a huge number of film makers, choices, prices, and other options. A quick trip to the professional photo store will help you sort out these options. Fuji, Kodak, Agfa, and Ilford are the major players in the film business. We have tested and used nearly every make, model and type of film available. To be honest, most of them are pretty good. One or two are outstanding.

What do you want from your photography? Color prints, slides, black and white prints, or digital images on a Photo CD disc? What kind of situations do you want to shoot? Do you plan to shoot mostly outside in sunlight, inside with low natural light, inside with a flash, fast moving subjects, or still life subjects? As a travel photographer, you'll probably want to do a little bit of all these things. Answer these questions as you read about the different films that are covered in the following outlines.

Color Prints and More

Making color prints, which means using color negative film, is the most common type of photography. What many people don't know, is that a good color negative will also make color enlargements, black and white prints, and color slides. They can also be scanned onto a Photo CD disc. Each of these processes is completed after the color negative is made.

Color negative film has the widest latitude of exposure forgiveness of the popular films available. What this means is that you can accidentally overexpose or underexpose this film a stop or two, and still get pretty good images. We don't recommend this practice, but knowing it's possible can save you when one of those accidental improper settings is made.

The majority of your normal daylight and flash travel photography can be made on the following color negative films: Kodak Gold 100 ISO and Fujicolor Reala 100 ISO films. Both films provide crisp and clean photographs that have colors close to, or better than, the original natural scenes.

Slides

Most of today's professional magazine and advertising photographers, including travel photographers, shoot for the printing press process. This almost always means shooting on color slide film which is also called *transparency* or chrome film. This is the least forgiving film, with almost no exposure latitude. Unless you are strictly interested in giving slide shows, we highly suggest sticking with the color negative films.

TRANSPARENCY

What professional photographers call a slide that is larger than 35mm.

The majority of your normal daylight and flash travel photography can be made on the following color slide films: Fujichrome Velvia 50 ISO, or their normal Fujichrome 50 ISO, They *are* different. The Velvia is best for travel photography, providing bright colors and contrasty slides that seem snappier than nature provides. The normal Fujichrome is closer to nature.

High Speed Films

If you are shooting fast moving subjects in lower light situations, interiors and other situations where 50 and 100 *ISO* films aren't enough, there are some options. Kodak offers their Gold Color Print film in 200 and 400 ISO versions; Fuji has professional color negative and slide films in the same range. These higher ISO numbered films are more sensitive to light, and work when there is little other choice. An increase in sensitivity often results in softer pictures.

Most of the film makers offer super speed films, some in the range of 1000 ISO and higher. These films make interesting shots in places where you can't use a tripod or a flash with slower films. Shooting concerts, folkloric dance groups, and natural light inside portraits are examples of their possible use. With super sensitivity over 1000 ISO comes even softer pictures, with grain, that give the appearance of looking through a screen door. Some of the lower ISO speed films, ISO 50 and 100, can also be "push processed" for greater sensitivity. This is covered in the processing section.

Other Films

Black and white developing is something many people like to do at home, using their own dark room. Today, most black and white shooting is done by photojournalists, news, and fine art photographers. It requires a good hand in the darkroom.

Infrared photography is a creative, surrealistic approach to photography. It's available in color and black and white films, but is strictly for playing around, not your usual travel photos. Professional portrait and commercial negative color films, used mostly by studio shooters, are excellent for getting color prints of natural flesh tones, pastels, and other softer colors.

You may prefer these films' more subdued natural look, over the brighter contrast of our earlier recommendations.

Test Test Test

No matter which film you're interested in using, or what the expected end results, test and compare several different types before making a big purchase. Make your film tests under the same lighting conditions, and with the same camera lens combinations.

Try everything: natural light, full sun light, dusk, night, and electronic flash. Tell the processing lab when you're doing a film test and ask them not to make any improvements or changes during their printing so you can judge the results.

ISO

International Standards Organization, which sets the light sensitivity rating for photographic films.

The ISO rating has replaced most of the older ASA American Standards Association ratings. Either set of letters generally appear before a number, such as ISO 100 or ASA 100.

"...TEST AND COMPARE SEVERAL DIFFERENT TYPES..."

Where can you get film in an emergency? In just about any small picturesque village, in just about any country. Don't speak the local language? Just show them one of your exposed rolls, and capitalism will prevail. Village of Tequila, Central Mexico. Made with 50mm lens.

Processing

Use a custom lab for processing your film. This is the last technical step in getting good travel pictures. Take a little time and visit two or three professional labs, pick up a price list, get a tour, and see what they can do for your work and money. Custom labs can help you with lots of excellent advice on film, processing, and printing.

> **"USE A CUSTOM LAB FOR PROCESSING YOUR FILM."**

One Hour Prints

The one hour and drug store film process and print drops are great for giveaway snapshots. Some can even provide better quality prints and enlargements. Most can't equal the quality, or high price, of a custom lab. In processing, you generally get what you pay for.

Some film drops are outlets for excellent amateur processing labs. Some custom labs also offer basic and amateur services under a different name. Ask around. Run a few test rolls, and see for yourself.

Processing Trip Shoots

Unless there's some kind of an emergency, and we can't think of any that fit, don't process your film while on location. Bring film home, and process it at a lab that you've tested. Don't process 100 rolls of film

from your around the world cruise all at one time. Split your film and process it in several batches on different days. This is just a precaution to make sure everything is working correctly at the lab.

Push & Clip-Tests

You can increase the ISO speed of your film, by two and three times the listed rate, with special processing at custom labs. You must shoot the entire roll of film at the increased speed, which must also be set on the camera. Use this *push processing* when you get caught in a low light situation, have to shoot aerials at a higher shutter speed, under water, and other times when faster ISO film isn't available, or when you've accidentally changed the setting on your camera. Talk with someone at your custom lab about push processing, and testing this process, before resorting to it on an important subject or trip.

If you're not sure what ISO rating the film has been exposed at, you can also request a *clip test* process at custom labs. They will process the first few inches of film and show you the results, after which you can make some corrections in processing the rest of the film. Some professionals clip-test a few rolls, from a major bulk shoot, just to make sure everything is going well before running all of their film.

Enlargements

In making enlargements, start out by making test prints at the same lab that processes your film. If that works out well, stay there. If not, ask for a good recommendation from your professional photo store.

If your original negative or slide is exposed properly, it should make an excellent enlargement, even wall sized. Focus and shutter speed must also provide a sharp image to make such enlargements. For the best enlargements, Fuji High Gloss printing paper should be requested at a custom lab. Color slides tend to print a little darker than the original because of their contrast.

If a custom lab can't print slides to your satisfaction, have them make a color internegative from which to make prints. Making internegatives might also be a good idea for protecting those "once in a lifetime" slides which can be damaged from too much handling and printing.

Electronic Photography

With the proper computer equipment, sometimes available at a custom lab, you can take just about any slide, negative, print, or other image, and scan it onto a CD Photo Disc (Made by Kodak). With this disc, which holds up to 100 images, and a simple player, you can have a slide show on any television. With a little help, you can add music, graphics, and timing to the show.

Your Photo CD images can also be changed or manipulated in thousands of ways. For example, you can add a blue sky where it was gray; add or remove sunglasses, or swim suits for that matter; put a face in a silhouette; change the color of a car; put several images in one shot,

PUSH PROCESS

When a custom processing lab increases the ISO of film because it has been exposed in lower level light situations.

The entire roll must be exposed at the same ISO setting. For example, ISO 400 film can be push processed as high as ISO 1600.

CLIP TEST

Processing the first few inches of a roll of film to determine if the exposure is correct.

The processing time can be changed after examining the clip test to correct improper exposures.

It is available from professional custom labs.

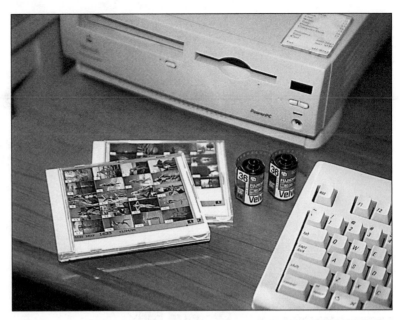

Today's travel photographer might make an image on film, transfer it to a Photo CD, then into a computer, where it can become part of a program, enhanced for printing, or stored for future use.

and even create some bizarre futuristic images. Again, you need the right equipment and software, or the help of a good custom lab. Some of these processes are so good that manipulated images can be output into color slides, color prints, and separations for the printing press that are equal to, or better in quality, than the original image.

If you have an interest in learning how this exciting technology works, talk with graphic design schools and computer sales outlets to find out what it takes to get up to speed. They can tell you what kind of investment in time and money is required to create images in this exciting new field of photography. Remember, it still requires good images to work from when using these new computer graphic systems.

Buying Materials

Scrimp on the price for a roll of film, or the processing of that film, and you may also scrimp on the results. Buy the best you can afford; the price will be forgotten long after the quality is remembered.

Buy your film in bulk, at least 20 rolls at a time, and store it in a cool place (the refrigerator is fine) until it's time to shoot. Bulk film buys often give the best prices and same results from the first shot to the last in every roll. Just remember to allow film a little warming time when removing it from a cool place before shooting.

You will notice that professional photo stores have most film in a cooler. This prolongs film life and quality. Some of the discount places, catalog houses, and variety stores, buy in huge quantities and take care of film. Some do not. Look around, ask around, and remember how important film is to the picture. And, test-test-test everything.

"BUY YOUR FILM IN BULK, AT LEAST 20 ROLLS AT A TIME..."

Chapter 4

TRAVEL PLANNING AND PREPARATION

Photographers don't plan to fail. However, many photographers fail to plan for their trips. As a result, they often are unhappy with the shooting opportunities, weather, schedule, and ultimately, their photos.

Organize Early

Once you've decided where to make a serious photo trip, set a firm date, even if it must be changed later. The more time you allow for trip planning, the better. Five or six months isn't too early to start a travel planning schedule, and begin location research for producing great travel photography.

ORGANIZE EARLY:

- Trip Notebook
- Checklists
- Travel and Location Research
- Itinerary
- Documents
- Language
- Packing

The traveling photographer often gathers things when planning trips to strange places. The planning that takes place before leaving home, helps make a perfect trip.

"FINDING OUT WHEN THE WEATHER IS IDEAL FOR PHOTOGRAPHY ...IS PRETTY EASY"

TRIP NOTEBOOK

A three ring binder that contains everything connected with your trip. It should be taken with you when you travel.

Weather is Everything

Summer is hot, humid, and rainy in the tropics. Winter is cold and dark in non-tropical climates. Obviously, there are much better times to make travel photos in these places.

Finding out when the weather is ideal for photography, in any location, is pretty easy. The local library, bookstore, or the Internet, will have a variety of travel information and guides providing specific weather and climate ranges for your destination.

Do not rely on resorts, travel organizations, airlines, tour companies, or tourists for photography shooting weather information. Most of these people think a bright sun and clear sky are ideal for photography. Some of these people will also "enhance" their descriptions of weather conditions. All of these sources are great for travel research information, but not for weather.

If you want good first person information about weather, other photographers are the best resource. Professional photo organizations, such as the Professional Photographers of America, have members throughout the world listed in their directories. Most will be happy to answer a brief letter that includes a self-addressed stamped envelope. Some of these photographers will also be interested in meeting a fellow photographer from another country.

Trip Notebook

The first thing you need to do is start a *trip notebook*. Eventually this will contain everything connected with your trip, and should go with you on the trip.

A soft-covered, two-inch, three-ring binder will do the job. This is not the place for your travel tickets, documents, or travelers checks, which should be kept together in a secure place until departure.

Your trip notebook should contain the following:

❏ Trip Schedule
❏ Daily Schedule
❏ Airline Routes Schedule
❏ Location Maps
❏ Trip Checklists

Lists of:

❏ Addresses-Phone Numbers
 Family, Friends, Medical, Business
❏ Location Information & Contacts
❏ Travel Agent-Airline-Hotel Contacts
❏ Location Events & Attractions
❏ Basic & Emergency words in local language
❏ Equipment Lists w/serial numbers

Photocopies of:

❏ Travel Documents
❏ Credit Cards
❏ Insurance Papers
❏ Medical Prescriptions
❏ Travelers' Checks
❏ Guide Book Information

Checklists

People who travel frequently often rely on checklists to make sure they have everything necessary for a trip. This is especially important for photographers, who carry a wide range of equipment and paperwork. Over the years we've developed a good set of checklists which are copied and put into the front of our trip notebooks:

Documents:

✔ Passport
✔ Extra Passport Photos
✔ Airline Tickets
✔ Airline Route Schedule
✔ Equipment U.S. Custom Registration
✔ Medical Prescriptions
✔ Emergency Contacts
✔ Insurance Papers
　　Photo Equipment
　　Medical
✔ Trip Notebook
✔ Xerox Copies of All Documents

Names, Addresses, Phone & Fax Numbers:

✔ Travel Agent
✔ Airline/s
✔ Hotel/s
✔ Family
✔ Medical
✔ U.S. Embassies
✔ Banker

Photo Equipment:

✔ Equipment List
　　Serial Numbers
✔ Film
✔ Camera System
　　Bodies
　　Lenses
　　Filters
　　Tripod

Flash
Case
✔ Extra Batteries
✔ Equipment Manuals
✔ Plastic Freezer Bags
 Small Medium Large
✔ Gaffer Tape
✔ Marking Pens
✔ Repair Tool Kit
✔ Flashlight
✔ Swiss Army Knife
✔ Scissors
✔ Polaroid Camera & Film
✔ Equipment Lists w/serial numbers
✔ Photocopies of All Documents

Travel & Location Research

"**K**NOW **BEFORE YOU GO.**"

"You should have been here last week," is a phrase travel photographers don't want to hear. The U.S. Customs people have a slogan "Know Before You Go," and we completely agree with their assessment of traveling. The more you know about a location, traveling, and travel photography, the better your trip and photo opportunities.

Keep photocopies of the best location research information in your notebook. Use a hi-liter marking pen to outline anything that seems important to your trip. There are hundreds of places to get research travel information. Most of this information and accompanying literature is free for the asking.

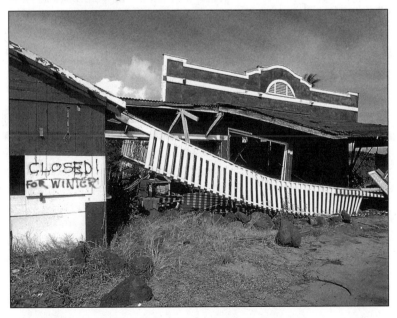

"Know before you go," is the motto of U.S. Customs. Always check that your winter accommodations haven't blown away in a hurricane. Poipu Beach, Kauai, Hawaii. Made with 35-70mm zoom.

"YOUR TRAVEL AGENT WILL BE THE SINGLE MOST IMPORTANT LINK BETWEEN YOU AND THE DESTINATION."

CONSULATE

An office representing a foreign country where a fully staffed Embassy isn't practical.

Most consulates issue visitors visas, provide tourism information, and provide other business information for their country.

The same services are also provided by an Embassy.

Travel Agents

Your travel agent will be the single most important link between you and the destination. They will have, or be able to find, information regarding customs, visas, travel times, accommodations, restaurants, attractions, events, and tours.

The services of a travel agent are generally free, especially if you book a major trip. While agents are good resources, they are also very busy. In order to help, they need to know, in general terms, where, when, and why you plan to go, and a budget range. The more advance time you give an agent, the better their services and information.

Ask friends and business associates to recommend a good travel agency or agent. Call the agency and ask if they have someone who has traveled in the region you want to visit. An agent's first hand knowledge means they have personally inspected the places they recommend.

U.S. Government

There is a lot of travel information and literature available at most passport application offices. Our government keeps track of things such as the safety of travelers in all foreign countries, immunization requirements, and any unusual customs necessities going and coming home. If you have a specific question, or are worried about loosing contact in some remote location, there is probably a U.S. *Consulate* in the area where you can write for additional information. Ask at the passport office. Keep the addresses and phone numbers of U.S. Embassies and Consulates in the areas where you intend to travel. When an emergency arises, they should be your first call.

U.S. Customs offices also have literature available regarding what you can and cannot import into the United States and other countries.

Passports and Customs are covered in greater detail, later in this chapter.

Tourist Organizations

Tourist Organizations, sometimes called Visitor and Convention Bureaus, have the best travel information available. They love getting requests from serious travelers. It's why they exist, and it keeps them in business. Many of these organizations have offices in major U.S. cities. Contact their national offices. Find their numbers in telephone books at the library, through their international airline, or through your travel agent. Tourist organizations are the people who live in and know the destination. Their information will tell you about special celebrations, cultural events, unusual activities, attractions, parks, and a hundred other things that are perfect for photography.

Tour Companies

Some travelers enjoy taking pre-packaged tours which can include air, hotel, some meals, structured destination tours, workshops, and entrance to events and attractions. Specialty photography tours are

available to some of the world's most exciting and photogenic places. Well-known professional photographers, writers, and authors often give workshops in interesting locations. Travel agents can find and recommend some of these programs.

You can find specialty tour organizations through their advertisements in photo, travel, and similar publications that feature subjects in which you are interested. Once you've located a potential tour, have your travel agent do the administrative legwork and book the trip. By doing this, you can pay with a credit card, and eliminate potential problems should the tour operator be unable to provide the program.

Editorial Resources

Check the magazine rack for publications that feature the subjects and locations you want to photograph. If you have a strong interest in traveling and photography, you may already subscribe to one or two of the better publications. Most city libraries also have excellent publication files on a wide variety of locations. You can read through a year's worth of issues, photocopying some of the better articles.

There are also a number of very nice pictorial books, also called coffee-table books, available on various locations. When a photographer is good enough to publish a location pictorial, the images are inspiring examples. The photo pictorial books are also starting places for finding good shooting techniques.

Several pictorial books, editorial resources, and references are listed in Appendix A.

Asking For Information

When contacting any resource for information, it's best to make the first effort through the mails, by fax, or the Internet. Write a simple request that lets them know you're an amateur travel photographer who plans to visit such and such a place. Keep things general. You should receive a nice package of brochures and travel information.

Once you've evaluated all the resource information on a destination, there may be a few unusual subjects you want to see and photograph. This might include a religious ceremony, a small village, a cultural dance class at a university, a musical group, a local artist, or similar things. Maybe you would like to tour a local factory, brewery, ranch, farm, school, hospital, church, orphanage, or meet an interesting family. Once you have some specific things in mind, contact the tourist organization and let them know what you're interested in seeing and photographing. Ask for their help in scheduling your visits, preferably with an English speaking guide.

Write as far in advance as possible. Always tell them you wish to take pictures that are for your own use and not for any commercial use. Ask for a written confirmation which gives you a contact name, phone number, and directions to a meeting place. Give them your hotel name and phone number. Confirm again when you get to the destination, and always be on time, no matter what the local custom. Bring a few small

Most of the world's destinations have been the subjects of photo features in a magazine. Places to check for magazine articles: National Geographic Society, your library, the Internet, and writing directly to a tourist organization.

If you have a special interest, a little advance planning might open doors to produce related travel photos. Rose Garden, Bangkok, Thailand. Made with 35-70mm zoom lens.

"USE THESE WORDS OFTEN – AND SMILE."

gifts from your home town, something for children, and a few snapshots of your home, city and job. Exchange names and addresses, business cards if possible, and follow-up with a thank you note and a few small prints from your visit.

Learn to say "hello," "please," "thank you," and "excuse me" in the local language. Use these words often – and smile. Knowing how to ask for the bathroom might also come in handy.

Computer Research

If you're into computers, some of the new "on-line" services offer international communications and have huge libraries of information, including travel subjects. Much of the information and research may be available for your travel destinations, as we've suggested, via the Internet.

You might also be able to communicate with photographers and photo subjects in foreign locations. This is still a new, but very exciting technology, and method of communicating and researching.

Itinerary

When planning a trip, the itinerary should be as simple as possible. Don't try to see a dozen cities in as many days. Better to see two or three different places on a two-week vacation. Moving from city to city, especially by air, has become more hassle than pleasure, with security, conventions, business travelers, and airlines that act like bus companies. This is where your travel agent can make things easier.

"TRY TO ARRIVE AT DISTANT LOCATIONS LATE IN THE AFTERNOON."

Try to arrive at distant locations late in the afternoon. Check into your hotel, have dinner, walk around for an hour or two, and head to bed after a long hot shower. This will help you get started in the local time zone and be ready for a full day of exploring and shooting.

Scheduling for Photos

Once you have a general city by city and country travel itinerary firm, start thinking about your daily schedule. In warm weather locations most travel photographers schedule their scenic subjects early in the morning, or late in the afternoon, when the light is at its best. People and attractions are best in the morning before 11am and the afternoon after 3pm. The high noon hours, 11am, through 2pm, are too harsh for most outdoor photography. Use these hours for a swim, lunch, and relaxing. In winter locations, shooting hours are all the daylight hours.

If you're not on a structured trip, and spending several days in a location, book a city or general area bus tour on the first morning. This will give you a quick overview of what to expect. Keep your notebook handy, and ask the local people questions about the activities and attractions in your daily schedule.

Schedule an activity or attraction for one half day, which is probably more than enough time to make photos. This will give you some extra time to look around the general area for other subjects. Leave at

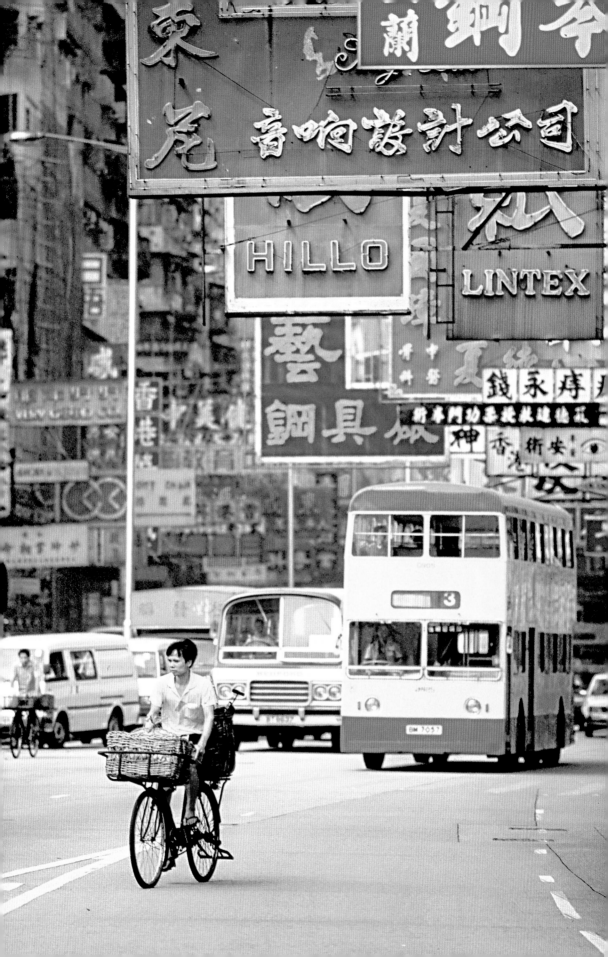

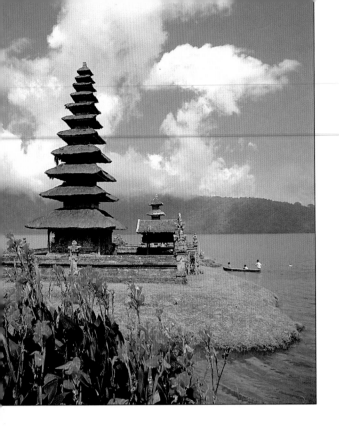

Previous page: *Nathan Road, one of the busiest and most interesting shopping streets in the world, is compressed when using a longer telephoto. Kowloon, Honk Kong. Made with 300mm lens.*
Left: *The Ulundanu Temple photographed against white clouds, and a lake reflection, makes its unusual shape stand out. Bali, Indonesia. Made with 35mm lens.*
Below: *Sub-zero temperatures of -50 Fahrenheit greet this Alaska Airlines jet at the Dead Horse Airport. Prudhoe Bay, Alaska. The photo was made at noon, when there was about five minutes between the Arctic sunrise and sunset. Made with 85mm lens.*

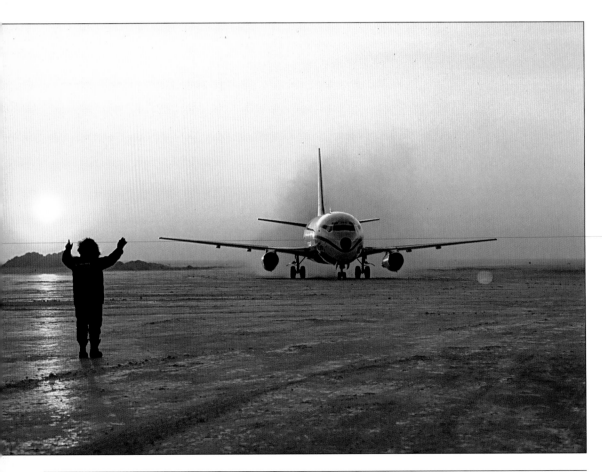

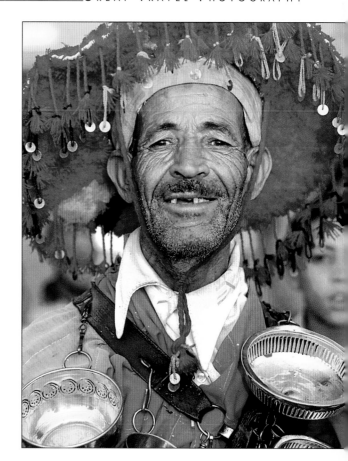

Right: Water salesmen, in Moroccan public markets, are very willing and colorful photo subjects — for an American dollar. Marrakesh, Morocco. Made with 35-135mm zoom lens.

Below: Blue sky and water is enhanced against the white clouds and beach with a polarizing filter. A small rubber boat adds a little life to the scene. Hawksnest Bay, St. John, Virgin Islands. Made with 24mm lens.

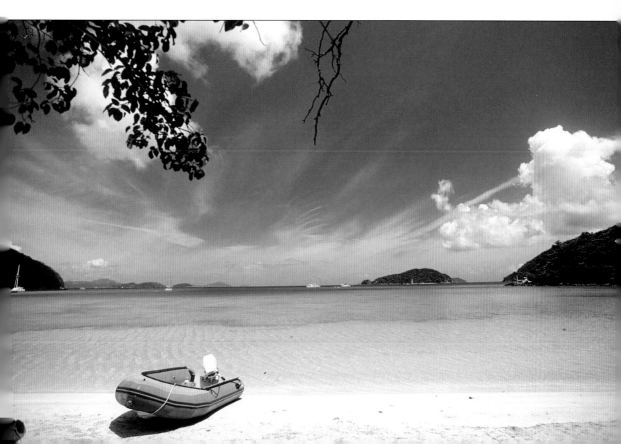

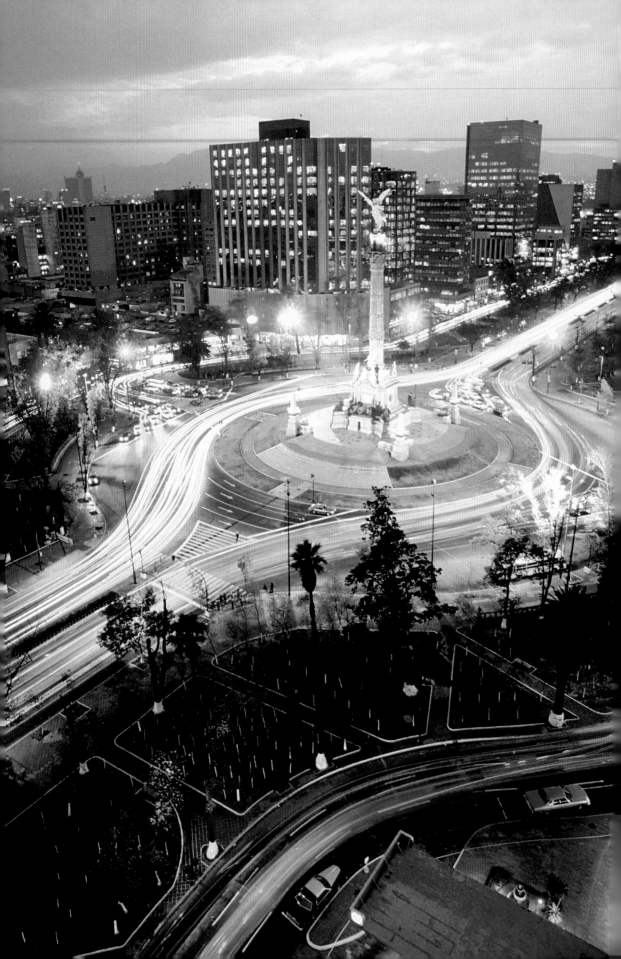

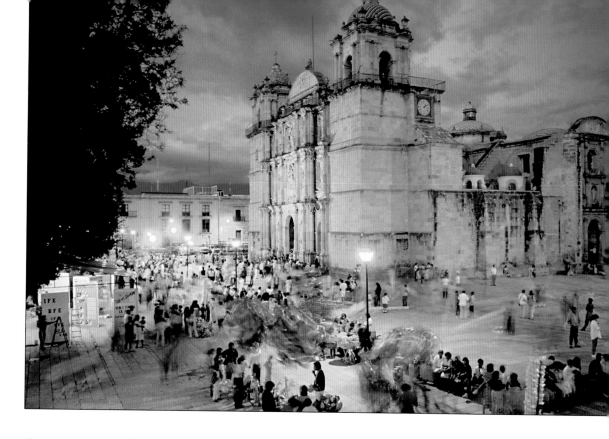

Opposite page: The motion of early evening traffic swirling around the Angel Monument, is shown when photographed with the lens open for ten seconds. Mexico City, Mexico. Made with 18mm lens and tripod.

Above: A Sunday night scene, at the main plaza and cathedral, seems to come alive with just a little motion. An exposure of 1/2 second and a tripod were used. Oaxaca, Mexico. Made with 28mm lens.

Below-left: An unusual view of the Maria Gern Church was made by climbing the nearby hillside. Berchtesgaden, Bavaria, Germany. Made with 35mm lens.

Below-right: A graduate neutral density filter was used to reduce the white in Mt. Rainier, in front of a much darker blue sky. Reflection Lake, Paradise, Washington. Made with 24mm lens.

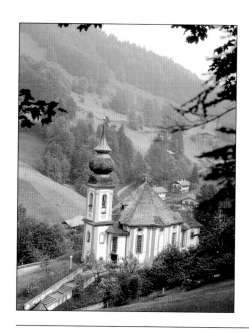

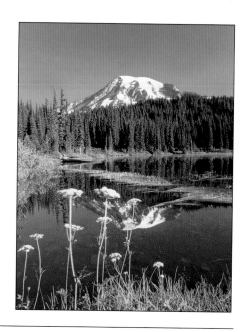

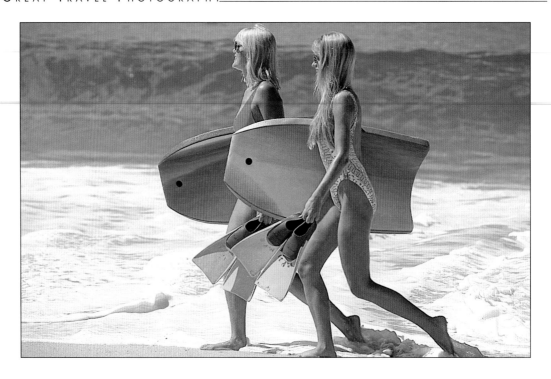

Above: *Two colorful boogie boarders head for the surf at Big Makena Beach. Wailea, Maui, Hawaii. Made with 80-200mm zoom lens.*
Below: *The white church at Sacre-Coeur and surrounding flowers and grass stand out against the sky when using a polarizer. Paris, France. Made with 24mm lens.*

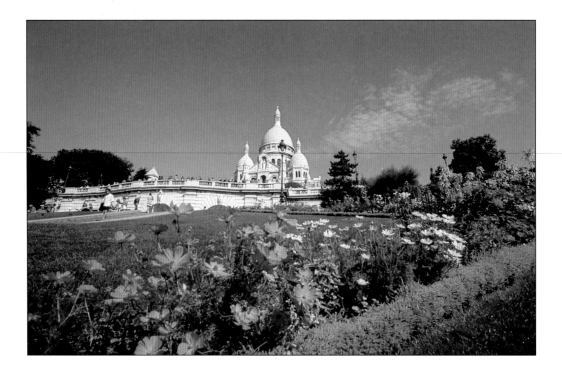

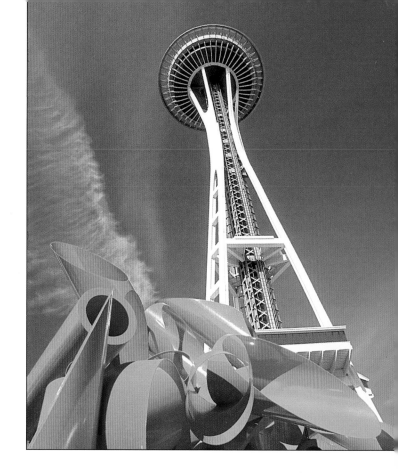

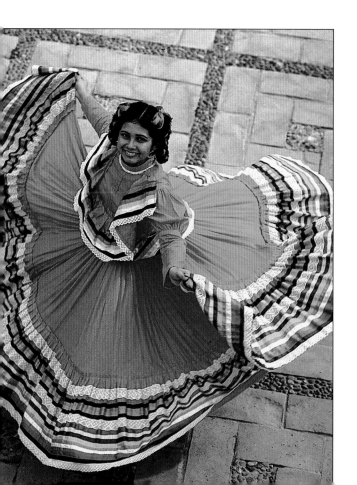

Above: An interesting perspective is made of the Space Needle by shooting from a low angle and using the frame of a bright red sculpture. Seattle, Washington. Made with 18mm lens.

Left: Mexican folkloric "Ribbon Dress Dancer" shot against the patio of the Krystal Hotel. Puerto Vallarta, Mexico. Made late in the afternoon light, with an 85mm lens and flash film.

Above: *Handicrafts in a tourist market make an interesting pattern when photographed in a tight shot. Zihuatanejo, Mexico. Made with 80-200mm zoom lens.*
Below-left: *By using a long lens, that is focused to it's closest possible setting, this palm branch stands out against a setting sun. Dubai, United Arab Emirates. 180mm lens and a sunset graduated filter.*
Below-right: *A macro lens close-up of the inside of a hibiscus flower, which is less than 2" in size. Luzon, Philippines. Made with 55mm macro lens, additional close-up extender and tripod.*
Opposite page: *A lone gondola is framed by the Grand Canal, as the sun sets. Venice, Italy. Made with 80-200mm lens.*

least two half days completely open. These are the times to return to something you missed earlier, perhaps a place or activity someone has suggested, or to make up for poor weather.

Above all, be flexible. If you see something interesting to shoot, and the light is right, start shooting. Never say I need to be somewhere else in ten minutes and will come back later. In other words, never pass up a good shot because you probably won't get it back again. If a certain activity, attraction, or event isn't what you expected, move on to something that's better. Don't be afraid to leave a group, stay behind, or just skip something all together.

Go out and explore and get lost — so long as the areas are safe, and you can find a phone or some method of returning to a known spot. Don't be shy of the locals, even if you don't speak much of their language. Few people in the world don't understand a smile, a camera, or a stick of American chewing gum. Travel at your own speed, and remember that things always take longer than anticipated. Plan plenty of time to rest during the hottest part of the day. Keep an open mind and your sense of humor.

"GO OUT AND EXPLORE AND GET LOST..."

Documents

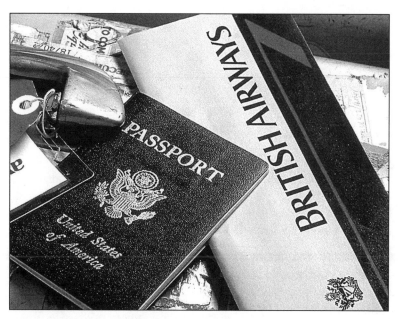

Your passport and related travel documents are important. Keep them locked in the hotel safe, or secured in a body wallet. While these items can be replaced, the hassle might ruin your trip.

Passports

A U.S. Passport is the best international identification document available for the general traveler. It is recognized by all foreign governments, even those who don't have diplomatic relations with the United States. Some foreign countries will allow U.S. citizens to enter with a

basic form of photo identification and a birth certificate. This form of identification always takes longer for processing than a valid passport. Most foreign countries require that a passport be valid for six months beyond the dates of a trip.

The State Department, which runs the passport office, recommends applications be submitted at least 30 days in advance of travel. An American Passport is more valuable than cash, and you should treat it accordingly.

Visas

Many countries require their visa stamp, in your passport, in order to enter their country. In some cases these *visas*, or a tourist card, are available upon entry into a country. Several countries require a completed visa application, and your passport, well in advance of any proposed travel. Your travel agent can take care of getting visas to most countries, so long as the U.S. has diplomatic relations with those countries.

In countries that do not have diplomatic relationships with the United States, you must generally take a specialty tour, or apply for a visa through a third country. For example, not long ago American travelers to Vietnam obtained their visas through Hong Kong, Bangkok, and other Southeast Asian countries. Again, a travel agent should be able to help point you in the right direction.

Keep in mind when traveling to these countries, that if you need any emergency help, it will have to come through the Red Cross, a major credit card company, your tour company, or some other business organizations with ties to the United States. Also keep in mind, if the United States has no diplomatic relations with a country, there must be a reason. Know before you go.

Health Certificates

Entering many countries, and returning to the United States, often requires immunizations against specific diseases. Your local health department, passport office, and tour companies can provide up-to-date information on the shots you "must have" and those you "should have" for proper protection. Get these shots well in advance of any travel or you may be getting them at some foreign country's immigration office.

If you have any unusual or complicated health conditions, alert your travel agent, the airline, resort, tour company, and an English speaking doctor in the location in advance of travel. Place a conspicuous note, regarding your condition, potential complications, treatments, and copies of medical prescriptions in your passport and *health certificate*.

Miscellaneous Documents

Your American driver's license is recognized in most foreign countries when renting a car. An International Driver's License may be required in some countries. Information on driving in foreign countries and International Driver's Licenses is available through the American Auto Association (see Appendix). If you plan to drive or rent a car in

VISA

Permission, generally in the form of a signed stamp in a passport, given to enter a foreign country by that country.

HEALTH CERTIFICATE

Similar to a passport, a Health Certificate lists the inoculations a person has received.

Most medical doctors and health clinics can give shots that are required by foreign governments for entry into their country.

This information is available at any passport office.

any foreign country, check with your auto insurance agent first. Insurance wise, they will probably advise you to take the rental company coverage. While this is often more expensive, it avoids the hassle of trying to get your hometown company to cover an accident or theft.

If you are a professional who requires a license to practice in the United States, carry a photocopy of your license and related documents. If you are an elected official, police officer, or hold other positions in the community or industry, carry some form of identification. You will be surprised how many doors can be opened, both socially and professionally, in other countries.

Not only will you often meet people in similar positions, but they will introduce you to celebrations and family events that make great photo opportunities. And, of course, there may come a time or incident in which your offer of professional assistance will be greatly appreciated.

Customs Here & There

Every country in the world has some form of customs inspection. In most cases, they are looking for illegal importation of drugs, technology, equipment, and other items which may be okay in America, but are illegal in the country you are about to enter. Information about what you can and cannot take into a country usually accompanies tourism literature. Do not take the laws of other countries lightly.

"DO NOT TAKE THE LAWS OF OTHER COUNTRIES LIGHTLY."

If you are returning to the U.S. with a foreign made camera and lenses, the Customs agent may not give you a second glance. However, if your equipment is fairly new, an agent may ask for proof of purchase, or a registration form. Without the documentation, you are subject to import duty.

All travelers are subject to U.S. Customs regulations when importing foreign made photo equipment, even if it was purchased in the United States. Custom agents will accept receipts, listing the equipment and serial number, as proof that the photo equipment was purchased in the U.S. If you don't have such receipts, or wish to leave them home, your equipment should be registered before leaving this country. Registration can be quick and easy.

All you need to do is visit a Customs Office, which can be found at any international airport, or by checking for other locations through your local phone book under the Federal Government pages. Register your equipment well in advance of travel, if possible, as they must actually see the equipment and record serial numbers.

Some foreign countries limit the amount of photo equipment and film that may be brought into the country.

Generally, if you look and act like a tourist, they won't bother to check. If you have several cameras and hundreds of rolls of film, and they see these items, you may be required to post a bond or pay a duty. If you plan to carry larger quantities of these items into a country, write their tourism organization, and ask permission to do so as an *amateur*. Permission will probably be granted without a hitch.

Language

We mentioned language earlier and we can't stress it enough. Learn to say "hello," "please," "thank you," and "excuse me," and smile in the local language. Use these words often. Knowing how to ask for the bathroom might also come in handy. No matter how bad you think you sound, trying to speak in the local language will be appreciated, and you will get better photos.

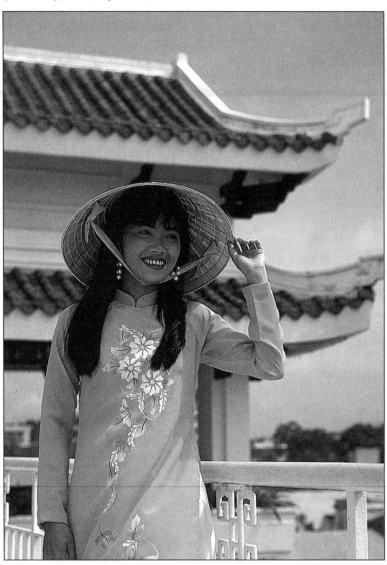

This young woman was visiting a friend at an airline ticket office when asked in the local language to pose for a few photos. Saigon, a.k.a. Ho Chi Minh City, Vietnam. Made with 85mm lens and flash fill.

"...JUST LEARN A FEW BASIC WORDS..."

Get a basic language program (see Appendix A) which includes a phrase book and pronunciation cassette. Don't try to become fluent; just learn a few basic words and phrases.

A wood salesman stops to be in a photo during his trip to a Saturday Market. We tipped him a dollar for his time and cooperation. Guadalajara, Mexico. Made with 85mm lens.

Make a list of the words and phrases you need, and find someone who can help you pronounce them correctly. A fun way to get some language practice is by visiting a restaurant featuring the food of the country you plan to visit. Call ahead to make sure someone actually speaks the language.

A candid photo always looks more natural than one that is posed. However, sometimes it's best to ask permission to make photos. You'll probably recognize situations when it's best to seek permission. Learn how to ask in the local language, or simply smile and point at your camera. Never ask, "May I take your photo?" This sounds like you want to "take" something from a person. Instead ask, "May I photograph you?"

Survival language:

Hello.
Good morning, afternoon, evening.
How are you?
What's your name?
Do you speak English?
I don't understand.
My name is
Please.
Thank you.
Excuse me.
Yes.
No.
How far to?
I'm lost.
I'm hungry/thirsty.
How much is this?
How much in U.S. dollars?
What time is it?
I am sick.
I need a doctor.
I need a telephone.
I need a taxi.
I need a bathroom.
I need a policeman.
Smile.

Packing

Airlines all have limits on the amount of baggage travelers can check and hand carry on flights. The limits are different between domestic and foreign; first class, business, and tourist classes. Your travel agent will know the limits. Find out what the charges are for excess weight and extra bags, both going and coming home. Most often, extra charges are levied in foreign airports on return flights, especially if you've purchased one hundred pound art object.

What Not To Take

Everyone knows to pack light, bringing only enough stuff for the trip. What you shouldn't pack are things that can be bought in the location at better prices than at home. Tee shirts, sweat shirts, shorts, and sun hats are examples. Buy them in the location, wear them, and give them away before coming home; it's cheaper than excess baggage.

Don't pack enough toilet articles for two months if you only plan to be away for two weeks. You can purchase these articles in special travel sizes, and many are provided by hotels. Go easy on shoes; they are heavy and bulky. Don't take a dozen lenses when two or three will cover the range of most shooting. Carry an extra camera body instead.

What To Take

Save room in your bags for extra film and batteries. These are the items you do not want to purchase in a foreign location. Hand carry your film in plastic bags which can easily be inspected by airport security. Bring along little gifts for children. They will open the hearts and doors of most parents.

Give yourself fifteen extra minutes before heading out to the airport on a trip. Use the time to review your trip notebook and checklists just to make sure everything is in order.

Security

Make sure your bags are difficult to unlock and open quickly. They should also be easily identifiable from a distance. One professional traveler buys bright pink bags that most people would rather not have, and has locking systems installed. He can always spot his bags, and knows they are secure.

Do not leave your bags unattended anywhere! That includes the airport ticket counter, a taxi, the hotel lobby, a restaurant, an event and so on. Make friends with other travelers, and watch out for each other's baggage. However, never leave your bags sitting alone, hoping a new friend will keep an eye out. We cover equipment and suitcase security, in greater detail, in the equipment and other chapters.

Insurance

Your photo equipment should be covered on a renter's or home owner's policy. Make sure by calling your agent. If it isn't, see what it takes, and the extent of coverage. Some insurance requires a special rider for photo equipment, especially if it's taken outside the United States.

The same goes for your medical, disability, auto, and life insurance. Make sure they provide coverage in the locations you travel, or have some other options available. Keep photocopies of all important insurance coverage papers, along with agent phone numbers, in your Trip Notebook.

"SAVE ROOM IN YOUR BAGS FOR EXTRA FILM AND BATTERIES."

Chapter 5

TRAVELING

Traveling should be a fun experience that is enhanced by photography. If you've planned ahead, as we suggest throughout this book, traveling will be fun and easy. Remember to keep an open mind, and always expect things to take much longer than anticipated.

Airlines & Airports

The majority of problems with airports and airlines, come from people who wait until the last minute. Confirm your flight and departure time 24 hours in advance. Check-in a minimum of one hour early for domestic flights, and at least two hours early for flights between two countries. You'll get much better service, and have fewer problems and mistakes, by taking this small amount of extra time.

Check-in for domestic flights at least one hour early; foreign flights, two hours early. This will give you time to make sure all bags are marked correctly, and that connecting flights are in order.

Actress Lisa Stahl shows how much baggage a professional travel film and photography crew carries on the average job. Wailea Prince, Maui, Hawaii. Made with 28mm lens.

"NEVER LEAVE A BAG SITTING ANYWHERE IN AN AIRPORT."

Baggage

Hand carry a camera body, lens, dozen rolls of film and toilet kit, in a small under-seat bag, onboard your flight. This will allow you to comfortably shoot upon arrival should your baggage be delayed. It will also allow you to shoot a few photos en route. Pack the remainder of your equipment, clothing, and travel items, and check it as "locked" baggage. Carry extra keys in your pocket and camera case.

Airlines carry millions of passengers and their baggage everyday, and experience few problems on the whole. Of course, you don't want to be the occasional exception and loose a bag full of camera gear. Checking in early, when the agents aren't as busy, is a good start. Always keep an eye on your bag tags, just to make sure they are marked for the correct destination. When you travel on third world airlines, that require a change of planes en route to your destination, it might be a good idea to check your bags from point-to-point — if there is enough time between flights for you to claim and re-check.

Put your name, mailing address, and phone number in several places inside and outside your bags. Keep an eye on your bags until they are taken away by the airline. Never leave a bag sitting anywhere in an airport. It will be picked up by a security officer or a thief, and delay your trip.

X-Ray & Security

All hand carried items, and most checked bags for international flights, are inspected by airport x-ray systems. Unless you use very high speed film (ISO 1000 and up), most of these systems should not hurt your film with one or two passes. Keep in mind, however, that x-rays are cumulative, which means their effect grows with each exposure, just like shooting several pictures on one frame of film.

We suggest that film packed in baggage be put in lead-lined film protectors, which are available at camera stores. This may require you to open the bag for a visual inspection, which is better than ruined film from multiple x-ray inspections.

In the United States, federal regulations allow you to request a visual inspection of any hand carried bag. Because security inspection stations can be busy, unbox your film and put it into a clear plastic ziplock bag. This will allow security officers to quickly see what's inside. Some foreign countries will visually inspect film packed in clear plastic bags, while others will only accept items passed through their x-ray machines. When no amount of discussion will convince security officers to give your film a visual inspection, pass it through the x-ray machines, and hope for the best.

Security officers are in airports to make sure that airports are safe places, and the bad guys and their weapons don't get on airplanes. They are not there to watch your hand carries or checked baggage. Some airlines provide security officers at baggage claim to inspect bag tags against claimed luggage; many do not provide this service. Don't

delay going to baggage claim when you arrive; try to be there when the flight's baggage is unloaded.

Documents & Paperwork

Keep important paperwork in some sort of small briefcase, or a secure pocket strapped to your body. Don't let this bag out of your sight. Don't ask a friendly passenger to watch it while you take a walk.

Some of the items your travel case should contain include:

- Tickets
- Passport & Visas
- Extra Passport Photos
- Health Certificate
- Travelers Checks
- Cash
- Location Guide Book
- Credit Cards
- Equipment Lists
- Customs Registrations
- Letters of Introduction
- Trip Notebook
- Daily Medication
- Some optional items:
 - Reading Materials
 - Walkman & Music
 - Small Portfolio
 - Laptop Computer

Customs & Cameras

Keep the U.S. Customs Registration Form, listing your photo equipment, and a few copies, handy. Some foreign customs inspectors will accept a copy of this paperwork for entry without requiring any duty. Morocco, for example, will attach a copy of any equipment registration inside your passport with their seal affixed. It comes out when you leave the country, after they carefully examine your gear to see that nothing is missing.

Some countries have their own customs importing forms which generally tell you exactly how much equipment and film can be brought into their country. In almost every case, they don't want people selling something in their country that requires an import or sales tax.

When you do have a problem passing photo equipment through a foreign customs inspection, keep a cool head and attempt to deal with the immediate agent. Some third world agents will accept a small "handling fee" if you are discreet about the offer. We suggest asking "Is there some small fee that will allow me to pass?" Never make this kind of a suggestion in a first world country, or you may end up getting strip searched.

"DON'T LET THIS BAG OUT OF YOUR SIGHT."

If there seems to be no easy way of passing through customs, calmly and firmly ask to see the agent's supervisor. Remind the agent that you are a tourist who enjoys taking snapshots, not a working professional who will be taking work from their nationals. Your professional identification, from another profession, may ease the entry. In the end, making a deposit or paying a fee may be the only solution beyond going home or having them hold the equipment during your stay. Should your equipment be held, or a high fine be required, notify the local U.S. Embassy or Consulate of the incident as soon as possible.

En Route Photography

Even the smallest airports can be exciting places to make travel photos. Since you're already carrying a camera, explore and photograph some of the interesting aspects of the airports along the way. See if there are any public observation points for photography. Be forewarned, most governments don't want their military aircraft and related installations photographed, even if you can see these subjects from a public observation tower. If there is any question regarding such subjects, ask someone in authority first.

> **"EVEN THE SMALLEST AIRPORTS CAN BE EXCITING PLACES TO MAKE TRAVEL PHOTOS."**

When traveling with friends, remember to make fun shots of each other along the way. This makes the long flights pass quickly, and also provides a few warm images for your slide show. Mexicana Airlines. Made with 35mm lens and flash.

If you're passing through a major airport en route to a smaller beach resort city, layover times can often be arranged for a few extra hours. After checking in and securing your seat on the continuing flight, grab a taxi and make a quick visit to the nearest tourist area. Even if you don't plan to take extra layover time, always research layover cities; you never know when a mechanical or weather problem will require staying in one of these cities for a few hours.

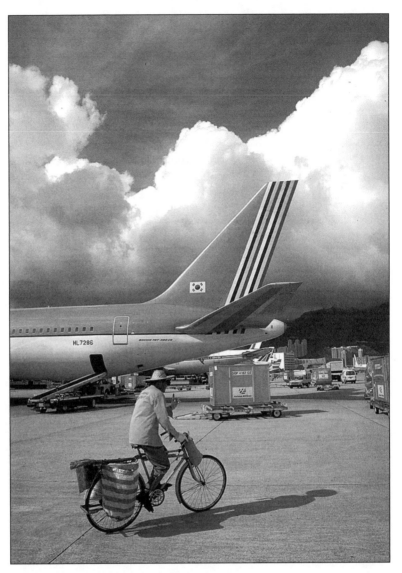

Some great photos can be made at airports, even during a stop for fuel. Kaitak Airport, Hong Kong. Made with 35-70mm zoom lens and polarizer.

En Route and In Location Research

Continue to research your destination while traveling. Strike up conversations with seasoned tourists, locals returning home, and employees of the airline. Many of these people will be interested in telling you about their home or previous visits. Show them your list of subjects scheduled for photos, and ask for ideas and suggestions. If it's appropriate, and they fit your needs, ask if they might like to pose for a few photos.

Watch for travel publications, inflight magazines, maps, and newspapers about your location along the way. Once you're close to the actual location, start looking for local news reports on events and

attractions. Tear out stories and photos of the things you want to see and shoot. Call the publication if you are unable to determine exactly where and when future events will take place. Ask to speak to their photo department where you might talk to someone who will show you around the event.

Safety

Act and look like you know what you're doing and where you're going when traveling and making photos. Keep your eyes open for people following you, especially in busy airports and around any crowded place. Use a little common sense in avoiding dark, quiet, and deserted places. If you get caught in a bad situation, where a person becomes a threat, remember that your life is worth more than your camera. We've heard of people dropping a handful of coins, and successfully running away in such situations.

Lock travel documents, extra cash, travelers checks, and exposed film in the hotel's safe. Lock all of your photo equipment in its flight baggage, and cable those cases to something solid in your hotel room. Tip the room maid and house person for "being so nice," and they will become part of your team, watching your room with a little extra care.

When scouting, exploring, and shooting, don't trust anyone to watch your gear while you make a shot. While it's a good idea getting to know your traveling companions, on tours and travels, these people might not watch your stuff closely enough to catch an experienced thief. Valuables normally kept in a pocket should be secured in a small body case where it is impossible for a pick pocket to reach.

Humor

"TRAVELING SHOULD BE FUN."

Traveling should be fun. Often things go wrong with scheduling, communications, weather, and plans that went so well at home. Smile, regroup, and get on with the trip. Something will replace the missed flight, event, or day. Laugh along the way, at yourself and the predicaments that pop up. In the end, you still win by reaching the destination and making beautiful pictures, while everyone else stays home and works toward their next vacation.

Chapter 6

GREAT TRAVEL PHOTOS

Shooting "good" travel photography is simply a matter of knowing how to use the equipment well, combined with planning to be in the right place at the right time.

"Great" travel photos are "made" not taken or snapped. They require all the same basics of planning, opportunity, and technical ability as good images, plus a few important creative capabilities.

A beautiful green field of taro. The blue sky and white clouds are enhanced with a polarizing filter. Hanalei Valley, Kauai, Hawaii. Made with 24mm lens.

Photographic Techniques

The best travel photos are immediately interesting to the viewer. They are well composed, in sharp focus, and have something that will draw the viewer's eye into the situation. As a photographer, you must see and shoot the interesting aspect of a scene, while taking care of

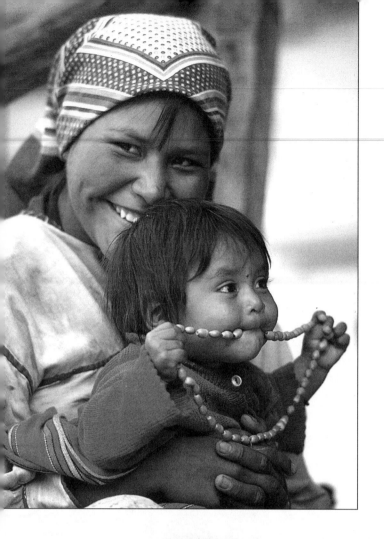

Left: *A Tarahumara Indian moth-
er and child selling her colorful
handmade crafts. Copper Canyon,
Mexico. Made with 35-70mm
zoom lens and flash fill.*
Below: *A young Tahitian dancer
performs the Ancient Hula. This
shot was made following her per-
formance in a tourist show.
Paradise Cove, Oahu, Hawaii.
Made with 35mm lens and flash
fill light.*

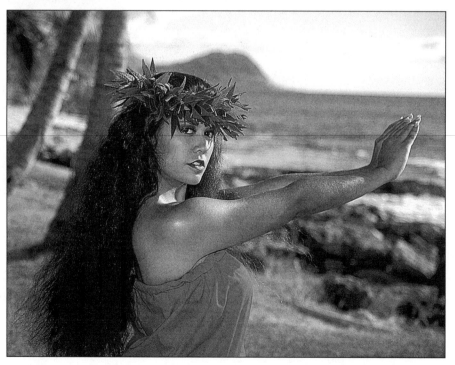

composition, focus and other technical considerations without a second thought. This must became a natural flow every time you see a photo, move to compose and focus, and watch for the perfect moment to make the exposure.

Seeking Ideal Situations

Once you've arrived at a planned location or activity, take a minute or two and scout for potential shots and subjects. As you explore the various situations, keep asking yourself, "Will this make an interesting photo?" When you're happy with the possibilities, start shooting, and keep shooting until the subject is well covered. Remember that film is the least expensive part of a trip.

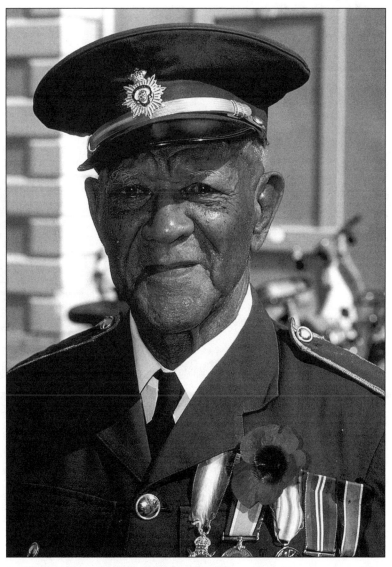

Celebrations provide hundreds of excellent photo opportunities. This old soldier is a good example, as he prepares to march in the Remembrance Day parade. Nassau, Bahamas. Made with 85mm lens and flash fill.

As you move and shoot around a situation, keep an eye out for something extra that is interesting or unusual. For example, at a theme park you might see dancers arriving for the afternoon's performance.

Don't be shy about asking one or two of them to pose before the public show starts. This will give you a chance to do something better than shooting up the noses of dancers while they are performing on a stage. If you can't make other arrangements, and have to shoot the performers on stage, back off a ways and use a telephoto. Also try to isolate individuals from the group. When asking professional entertainers to pose for special photos, remember they get paid for performing and should be offered a small fee or tip in advance of shooting.

"WATCH FOR THE UNEXPECTED MOMENTS AS YOU EXPLORE."

Watch for the unexpected moments as you explore. Keep your camera set and ready to shoot at all times. If something looks interesting enough to shoot, start shooting it immediately. Don't plan on returning to shoot later. Even though it's a good idea to keep moving and looking for photo opportunities, when you've found the ideal situation, it's also smart to be patient and watch for something to develop into a great photo. This may sound a little contradictory, but eventually experience and practice shooting will tell you when to move and when to wait for the right opportunity.

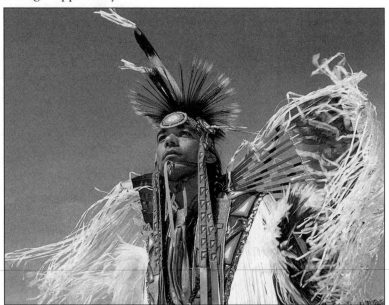

A contestant "Fancy Dancer" at an Indian Pow Wow celebration. This picture had to be made at high noon because of the dancer's schedule. The light was improved by adding flash fill and shooting up against a strong blue sky. Yakima, Washington. Made with 28mm lens and flash fill, shooting at 1/60th of a second.

Only sports and event photographers get good pictures by standing in front of everyone else. Try to blend-in with the surroundings, rather than jumping up at every opportunity to make a shot. This may seem difficult when you're obviously a tourist in a small country market. Start by using a telephoto lens, shooting from behind natural barriers. Let the

local people get used to your shooting and working at the edge of a scene. Once that happens, you can move in for closer opportunities. Of course they know you're a tourist, but getting the locals to accept your intrusion with a camera is the real challenge.

The people who support tourism activities and events often make excellent photo subjects themselves. This might be a lady steaming rice for a theme park's employees, a child watching through a fence or imitating a performer, someone in a gift shop, a painter repairing murals, a crafts person making items for sale to visitors, or a local family out for a Sunday visit. Look for still life subjects too, such as masks hanging for sale, folkloric dress items, crates of colorful fruit in the market, interesting hats, badges, door knobs, window flower boxes, coins, stamps, and similar items.

"LOOK FOR STILL LIFE SUBJECTS TOO..."

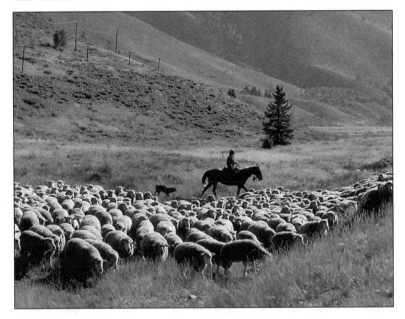

While driving to a resort area, we came upon this interesting scene of a rancher herding sheep on horseback. Sun Valley, Idaho. Made with 35mm lens and polarizer.

Bad is Bad

Travel photography should portray the things and places you enjoy seeing. If your eye says that something is missing from a location or activity, and there appears to be absolutely no chance for making good photos, then by all means move on to something or some place that offers better possibilities. If you do not approve of certain activities, such as smoking or begging, do not make them the subject of your photos.

Props and Possibilities

Once you've made the most apparent shots, ask yourself if adding something, or someone, will improve the situation. This may mean using your guide, or someone in the immediate area, to add a little life

Gondola paddler dolls stacked in a tourist market. Venice, Italy. Made with 55mm macro close-up lens and flash fill.

"ALWAYS ASK PERMISSION TO SHOOT ON PRIVATE PROPERTY..."

to a scene. People almost always like to participate in such requests. There probably isn't a single well-known tourism destination in the world that doesn't have hundreds of interesting props which can often help make people more interesting subjects too.

If you like the masks hanging in a store window, go in and ask a sales person to model one for a photo. Be sure to take them outside and shoot in front of their store as well. Ask where they are made, and if can you photograph the artist at work. Look around for any interesting locals willing to model some of the cultural clothing that is for sale in the shop.

Permission To Shoot

If you see a good situation, begin shooting photos as unobtrusively, and as soon as possible. Asking for permission generally reduces the candid and natural look of any situation involving people. If there is a problem, you can always ask for permission as you shoot. Be aware of the difference between someone wanting money for posing, someone irritated at your shooting, and someone that is turning hostile because of your activities. Many photographers have learned these subtle differences the hard way in public markets, by having fruit and vegetables thrown accurately in their direction.

Always ask permission to shoot on private property, at religious ceremonies, nude beaches, and any news event to which you do not have the proper credentials. It may be possible to join a crowd of tourists who are also taking snapshots of these subjects.

There are numerous places that do not allow any photography. This might include religious compounds, military installations, corporate offices, and some of the situations just mentioned. At Bangkok's Royal Palace, for example, officials do not allow photography of their famous Emerald Buddha, and will seize the film of photographers who ignore this rule.

On rare occasions, attempting to shoot photos will attract the attention of police or security officers who have the authority and ability to make your photo trip turn sour. Better to give up your film than visit the local jail or pay fines. The smile and the seeming ignorance of a tourist can defuse such situations, as might the payment of a small fee.

Tipping For Photos

There are very few tourist attractions that haven't been well photographed. This means you can almost always find good shooting opportunities and willing subjects. It might also mean paying a fee to enter a facility with a camera, or paying a photogenic local person to pose.

Many interesting people place themselves in good locations, in colorful dress, ready for photos. These people know they will make good pictures, and expect to be paid by passing photographers. A famous example, outside some of the walled cities in Hong Kong are elder Chinese ladies dressed in traditional black hats and robes. They offer to

Young Tlingit Indian "Button Dancer," during a welcome celebration for tourists arriving by cruise ship. Ketchikan, Alaska. Made with 80-200mm zoom lens.

pose for the equivalent of one U.S. dollar each. There isn't anything wrong with paying for photos like these, which might otherwise be impossible. Negotiate the price, and get your shots before paying.

If you see small children begging, and wish to give them money, a better idea might be asking them to pose for a photo, and then giving them a few coins. When children try to sell you small crafts or souvenirs, shoot photos of their hands holding the objects which you offer to buy if the price is right. At least these children will have learned something about the free enterprise system.

Children are also the way to the hearts of their older brothers and sisters, their parents, and other people in almost any place, especially a small country village. Children are smart, and will often go out of their way to help you find unusual subjects to photograph, mostly with them playing a starring role.

In some countries, children place a high value on posted stamps and coins from other nations, as a small gift. Keep a close eye on your camera bag and pockets during these sessions, because some cultures teach their children to be pickpockets at a very young age.

Talent

Experienced travel photographers occasionally hire professional talent for special picture taking sessions. Handsome men, beautiful women, cute children, and interesting older people who know how to make your photos look good, are available for hire. Many times such models have colorful cultural costumes, and will know interesting places to shoot.

Model agency and restaurant signs are found along colorful Beach Drive. South Beach, Miami, Florida. Made with 24mm lens and polarizer.

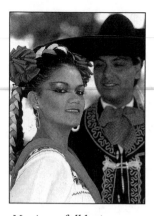

Mexican folkloric dancers pose for photos, following an afternoon show. Puerto Vallarta, Mexico. Made with 35-70mm zoom lens and reflector fill.

To hire models, look for talent, modeling, and advertising agencies in the area you are traveling. Contact them in advance, before you leave home if possible, and arrange to look at portfolios and headsheets. Tell them you are an amateur who wishes to make the best possible photos of their country.

You may need some assistance from someone who speaks the local language, although most professional people in foreign countries have a working knowledge of English. Select the models you wish to shoot, meet them in person first, if possible, arrange shooting times and locations, select clothing, and negotiate a price.

The cost can be a few dollars per day, up to several hundred dollars per hour. The rates are higher if you wish to use the images for advertising and need a release. Remember to send a few small prints to the models, and always make the offer allowing them to use any good images for their portfolio. This is an excellent way to make long lasting friendships.

The Movie Mode

Ever notice how the movies treat a situation? They start with a master wide shot which identifies what's happening in the scene. From this overall view, they begin shooting the medium individual and full-length people shots. Next they move in to get the faces and tighter close-ups.

This is also a good shooting procedure for most travel photography situations. Of course, if you see an great photo opportunity, immediately start shooting from any distance and make the other images later. Movie makers use their images to tell a story. Try thinking of your own shooting as if it were telling a story through still pictures. Somewhere in this story telling process, you'll find an outstanding travel photo.

How the Pros make Great Photos

Professional travel photographers evaluate every situation as they move around and shoot. They look for movement within the scene, and a story or action flow. They look for splashes of color, contrast, and light, always asking themselves what's happening, what's important, what's the best angle, and is there a better shot. They compare the subject with it's background, and ask if it fits or needs to be changed to enhance the photo. If the sky is bad or blank, they move to a higher vantage point using a telephoto lens, and eliminate it from the scene. Most often, a professional will move to and with the best light.

When you're shooting, keep moving. Change shooting positions frequently. Shoot high with a telephoto lens, shoot low with a wide lens, then do just the opposite. Imagine what the subject and situation will look like in it's final photographic form. Watch for interesting props. Shoot a still life photo of the prop first, then add it to a situation. Look for an interesting face, shoot it from a distance, and then move in to see what the person is doing or watching. Get a tight face, and then get a wide environmental shot with the person very close to the lens. Always keep an eye out for what the children are doing and watching.

Golden allegorical statue atop the Pont Alexandre III Bridge, in the late afternoon light. Left Bank, Paris, France. Made with 80-200mm zoom lens.

Working with Light

The visual quality of a photograph is determined by the quality of the light under which it is made. A nice rich and warm light adds a healthy natural look to any scene, especially faces and bright colors. That's why we recommend shooting during the "golden hours" from dawn to 10am, and from 4pm to sunset.

The best photographers learn to look for, and read, what the light is doing to a scene or individual subject. They watch for light coming through palm trees and bouncing off waves in the background, shooting the scene first, then placing someone in the foreground. They look for individual rays breaking through clouds onto a single rock or tree, shoot that scene, and then place the light on a small prop or interesting face. They move to the best light.

The perfect vacation picture. A hammock overlooking the sea at sunset. Kohala Coast, Big Island, Hawaii. Made with 24mm lens and graduated sunset filter.

Lighting Direction

For most shooting, it's best to keep the light behind your position and on the subject; assuming that you're shooting during the golden hours of the day. This will provide excellent direct light on your subject, and eliminate most problem shadows and harsh contrast.

Once you've shot the subject in direct light, move into a position where the light comes from the side. This will add contrast to the subject and background. Side light will also cast a heavy shadow on most of the subject not hit by the sun, and will be greatly improved by a fill light or reflector. This technique is mentioned later in this section.

After making a few shots with side lighting, move around the subject and shoot it with the light coming from behind, which means it will

SILHOUETTE

The dark shadow-like outline of something photographed against a light source.

be in your face. This will usually produce a stark silhouette, which is especially nice if done just before sunset. Silhouettes work great on people's profiles, palm trees, and other objects with a distinct shape that will stand out against the bright light.

In order to get a good silhouette exposure, set your automatic camera to increase by +1; on a manual camera, just open up an additional f/stop. If you see a great silhouette, always look behind you to see what is being front lighted.

Adding a strong fill light to a silhouette will allow you to shoot a face, or close subject, against a sunset, and still get good details in the face. This takes practice, especially with an automatic camera, to get the best results. Try shooting at +1 and at +2, on your auto exposure camera, or by opening up two f/stops in the manual mode for the first tests.

Fill Light

Most outdoor daylight shots of people, especially side and back lighting shots, such as those just described, will be greatly improved with a little "flash fill" from a small strobe light. Let your automatic flash figure the syncro sun fill light, or set your manual strobe so it will produce about one-third of the flash normally needed for a situation. You can multiply the film's ISO by four, and change the strobe's ISO setting for an initial test.

FILL LIGHT

Flash or reflector light used to brighten, or fill, shadows, such as those on a face caused by a hat.

An especially useful tool when shooting in bright sunlight.

For example, when using ISO 100, set the strobe at ISO 400, and it should provide just enough light to fill shadows in a face or under a hat. Remember to change these special settings back to normal. When shooting a subject that has a sunset directly behind it, use your strobe on full power for filling.

Professional photo stores have reflectors that can be used, like a mirror, to direct sunlight onto a subject for enhanced color and shadow filling. These round reflectors come in many sizes, from about 12", up to about five feet across, and quickly fold down to fit into a case about one-quarter their open size. Reflectors come in white (natural looking fill), silver (for overcast light) and gold (nice warm fill light). Using reflectors requires the assistance of a second person.

Color

Every film and lighting source has two or three colors that seem magical when photographed. Fujichrome loves bright greens, Kodachrome loves reds, negative print film loves most bright reds and yellows. And, as we constantly point out, almost every film seems to love light produced during the golden hours.

Once you know what your favorite film will do with certain colors and light, watch for opportunities to make them part of a scene. Add clothing or props that jump out from the scene, not only because of their interesting look, but also for their color. Make sure the light emphasizes the primary subject, and makes the color seem brighter.

If a color pops out to your eye, it will probably do the same thing on film. This might be a pile of fruit in a market, a brightly dressed per-

Left: *A beautiful sunset silhouette of a model against the ocean. Zihuatanejo, Mexico. Made with 35-70mm zoom lens.*
Below: *The silhouette of the model can be given a totally different look by using a flash fill. Zihuatanejo, Mexico. Made with 35-70mm zoom lens and flash fill.*

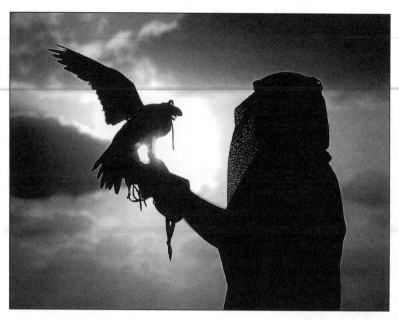

Above: Sheik Mohammed's Royal Falconer holds his bird against a blazing sky at sunset. Outside temperature was over 100 degrees Fahrenheit. Dubai, United Arab Emirates. Made with 85mm lens.

Below: Mexican cliff divers, shot against a full setting sun, challenge the travel photographer's skills. A shutter speed of 1/500th of a second was used to stop the action, while the scene was over exposed two f/stops to compensate for the bright sun. Divers require payment from all photographers. Acapulco, Mexico. Made with a 300mm lens and 85A warming filter.

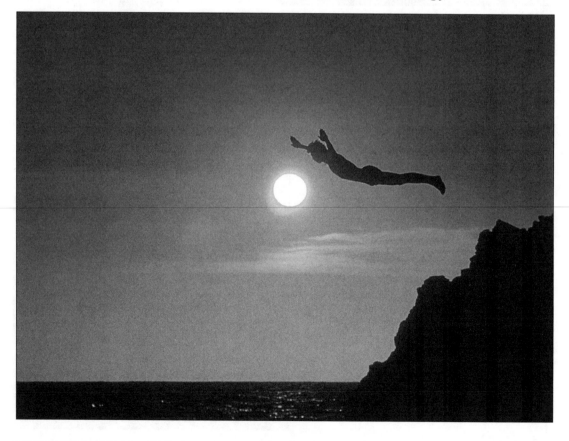

son at an event, something being carried by a beach vendor, and so on. Move around this splash of color with a telephoto lens, shooting it as the main subject, and then as the background for some other subject. Use the color and make it work for a photo. You will be surprised at how good some of these shots look.

Mood

Not every photograph you make needs to be loaded with hot colors, contrast, and movement. There are also many soft and moody situations provided by the diffused light of fog, mist, rain, overcast, and twilight, before and after daylight, that have excellent picture potential. A canoe sitting on a still lake in the misty early morning light; a couple standing beneath palms against the soft dusk twilight an hour after sunset; kids playing in the mist created by a rolling surf, and portraits in the diffused light against a rain soaked cut glass window, using a white reflector to fill the shadows, are a few examples.

Personal Touch

The best element of a professional travel photographer isn't a piece of equipment, but an attitude. Beyond an obvious love for the work, they enjoy the locations, cultures, and people. This attitude is immediately apparent to those people who are being photographed, and others who are watching. It shows on the subject's faces, and it will show through in your photography.

A genuine interest in who you are shooting, a word or two in the local language, and a friendly smile will always result in better treatment, and better image making. By now you've probably figured out that professionals are fearless in approaching people or situations to make photos. That's something you must also master. Just follow your smile.

Working at the Speed of Light

"THE BEST TRAVEL PHOTOGRAPHERS CAN ASSESS AND SHOOT A SITUATION VERY FAST..."

The best travel photographers can assess and shoot a situation very fast because their eye is accustomed to seeing the entire scene, and making the right photo decision. Meanwhile, their brain is used to operating the equipment as though it were part of their eye. They work a situation thinking in terms of photos....what a scene will look like in images, what the next opportunity should provide. They are always ready to shoot, seeming to know exactly what will happen next, where to be, and being ready when it does happen. They have learned these techniques through lots of practice, even more patience, and plenty of mistakes along the way.

Professionals also have another trick that makes sure their work is great. They show only their best work, generally throwing away anything that doesn't meet their standards. Your friends and family will be asking to see more photos if you only show them the very best shots from a trip. Show one bad photograph, and it might become the one they remember.

Chapter 7

EXTRAORDINARY ENVIRONMENTS

The world of travel photographers is as far reaching and exciting as their imaginations. The environments in which they travel and make photographs is also as varied as it is beautiful. Within this interesting world there are also some extraordinary environments we think you should know about.

Aerial Photography

Anyone who has ever taken a helicopter sightseeing tour around the island of Kauai, in Hawaii, knows the incredible beauty that awaits travel photographers. Helicopter photo flights are in fact, the best way to make aerial travel pictures.

Pilot

Always talk with your pilot before taking a flight to make photos. Sightseeing pilots know all the best places and altitudes. They have worked with hundreds of other people who also wanted to make nice shots. Use a map to highlight the areas you want to view, and possibly photograph, in advance. Try to sit directly behind the pilot so you see what he sees, and use the aircraft's communications system so you can talk with the pilot while in flight.

Altitude

Mexican helicopter pilot is a colorful photo subject, just before the start of an aerial photo flight over the Gulf of Mexico. Ciudad del Carmen, Campeche, Mexico. Made with a 35-70mm zoom lens and flash fill.

Government aviation administrations have very specific altitude regulations for sightseeing and photography flights. If you have a choice of setting the aircraft's altitude, try to stay below 1000 feet. Any higher, and you may experience a lot of haze. Try to keep the sun beside or behind your shooting position. This also eliminates some of the haze experienced with back lighting.

Photo Equipment

Your standard 35mm SLR camera is ideal for making aerial photographs. Make sure it has a well-attached neck strap, and that it is secured around your neck or wrist during flight.

Semi-wide and normal angle lenses, 35mm to 50mm, generally are best for most aerial subjects. A 28mm to 105mm zoom lens is excellent

Above: Wide-angle aerial of Biscayne Bay and Miami. Shot about 3pm from a helicopter flying at 200 feet. Miami Beach, Florida. Made with 24mm lens and polarizer.
Right: Semi-wide-angle aerial of Princeville on Hanalei Bay, at 7am. Kauai, Hawaii. Made from a helicopter flying at 500 feet, with 35mm lens.

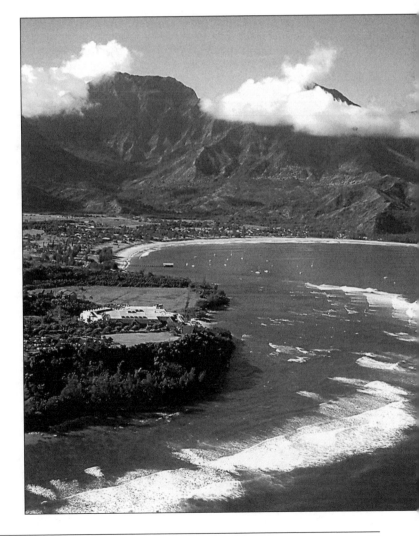

Above: Underwater close-up of a Moorish Idol tropical fish, approximately 30 feet below the surface. Current Island, Bahamas. Taken at noon, using ISO 200 slide film. Made with natural light, using a Nikon F4, with 50mm lens, in an aluminum housing.

Below: Snorkeler swims underwater for the camera, approximately 10 feet below the surface. Kealakekua Bay, Big Island, Hawaii. Shot at 10am using ISO 50 Slide film. Made with Nikonos Amphibious Camera, 28mm lens and flash fill.

EXTRAORDINARY
ENVIRONMENTS:

• Aerial

• Underwater

• Winter

• Tropical

• Close-up

for most aerial subjects. Super wide angle lenses, under 20mm, make nice horizon to horizon scenic aerials. Just remember to keep the aircraft out of your shot.

Exposure

Most normal daylight films with ISO's around 200 will produce excellent aerial pictures. Make your exposures the same way you do most other subjects, allowing the camera's automatic system to do the job. Shoot through an open window or door, or get as close to a clean clear window as possible, without actually touching the surface. Shoot at an angle, rather than straight down.

Shooting pictures from a moving aircraft requires a higher shutter speed of at least 1/500th of a second to make sharp images. If your camera, film, and light combination permit, set your shutter speed even higher at 1/1000th of a second. Make this setting in the manual mode with automatic cameras so it will not shift around as the lighting changes on your subject.

The best pictures are made by 11am or after 2pm on clear days with blue skies. Shooting an hour or so before sunset will produce some very nice moody pictures once you've done the daylight subjects. This will require using higher speed ISO films in the range of ISO 400. It's a waste of film to shoot at high noon on days with bright blank skies, or in heavy overcast light.

Filters

A polarizing filter will add contrast to a blue sky and improve the green in trees and grass. It will also remove some of the reflections on dark water, and make tropical waters almost invisible. Although some manufacturers offer haze-reducing filters, for the most part, they do little to remove haze. Your best bet is shooting on days when the haze, pollution, and mist are low. Make a few shots with and without filters.

Caution

If you're a pilot who wishes to make aerial photos, take another qualified pilot along to drive the aircraft. Flying is a full-time job, and doesn't need the distractions of shooting pictures at the same time. Again we stress, secure the strap of your camera to your neck or wrist so it won't drop out the window.

For that matter, make sure you are also very securely strapped in when shooting out an open aircraft door. It's against the law, and very dangerous to drop anything out the window of a flying aircraft. Remember, alcohol and many prescription drugs do not mix well with flying.

Underwater Photography

The underwater world is a beautiful and mysterious place that lends itself to excellent travel photography. Thousands of colorful fish, blazing coral, and the ever-changing brilliance of sunlight bouncing through

"THE UNDERWATER WORLD...LENDS ITSELF TO EXCELLENT TRAVEL PHOTOGRAPHY."

Tropical Killer Whales pose with photographer after an underwater photo session. Sea Life Park, Honolulu, Oahu, Hawaii. The camera is an Amphibious Nikonos with 28mm lens and underwater strobe. This picture was made with 85mm lens.

"YOU CAN ALSO MAKE FUN UNDERWATER SHOTS IN OUTDOOR POOLS"

SCUBA

Short for: Self Contained Underwater Breathing Apparatus, which generally means the tanks and breathing regulator used by a diver to breathe underwater. Thus the term "SCUBA Diver."

water can all be the subjects of your camera with a little training and practice.

Basic Requirements

In order to make underwater photos, you need to be an experienced swimmer, certified SCUBA diver, or both. We recommend taking a professionally instructed course in open water snorkeling and, if diving is your interest, a similar course in SCUBA diving. Your local YMCA, or a good dive shop, will be able to recommend certified training that will get you safely into underwater photography.

Experienced underwater photographers spend a lot of time in fresh water pools, testing equipment, and practicing their shooting and swimming techniques.

You can also make fun underwater shots in outdoor pools, but remember, exposurewise, there is generally a lot more light in pools than on the open ocean.

Dive Master

Make your underwater trips and photo dives with an experienced and certified Dive Master who has lived in the local area for few years. This will provide a two-fold benefit. Not only will your diving be safe, but a good dive master usually knows all the best photography spots, and may also be an experienced diver photographer.

Shooting Depths

The most colorful natural light underwater photos are made in clear and calm waters, less than fifteen feet from the surface. As you descend into deeper waters, the amount of surface light is greatly reduced, and most colors, except blue, are filtered out by the water. You can correct much of this loss on close subjects through the use of an underwater flash unit.

Diving Equipment

You can make underwater photos while wearing a basic face mask, snorkel, and fins. However, the longer you want to stay down, the wider range of subjects you want to cover, and the deeper you want to go, the more advanced equipment you will need.

The word *SCUBA* means Self Contained Underwater Breathing Apparatus. This is a fancy way of saying your air supply. Your safety depends on this equipment. Professional quality SCUBA and underwater gear can be rented from dive shops in most of the worlds popular tourism and diving areas.

Ask a dive shop in your hometown, or your SCUBA certification organization, to recommend a good shop. The better shops might also be able to recommend a local diving partner who is an experienced underwater photographer.

Do not skimp on SCUBA gear unless you wish to skimp on the air you breathe during underwater photo sessions.

There is little need to purchase your own diving equipment, beyond mask, snorkel, and fins, until you are an accomplished diver. By that time, you'll know which equipment is the best for your own diving needs.

Camera Equipment

There are two basic systems for making underwater photos: The amphibious waterproof camera and strobe light, and the watertight housings for your own camera and flash. Soft plastic watertight bags are also available for popular SLR cameras and small strobe units. These bags are fine for shooting just under the surface, or on rough river rafting trips. They are not intended for deep water photography.

As with SCUBA diving gear, we highly recommend renting both of these camera systems a few times before buying anything. The amphibious camera is a relatively small and easy to use stand alone system. The latest models have SLR viewing and automatic exposure. Likewise, there are some very good watertight plastic and aluminum camera housings available for most popular SLR cameras. With housings, the more automatic your camera, the easier the housing will be to use. Housings are about three times the size of your camera, and a bit bulky to handle at first. Make a few test dives with both systems.

Lenses

Wide angle lenses, 20mm to 28mm, make the best general underwater photos of subjects like people and schools of fish. Super wide lenses, around 15mm, are also available, and can make some very spectacular shots, especially against the water's surface and sun. Because everything is magnified underwater, lenses longer than 35mm focus better with close-up filters.

You can make some interesting close-up shots with macro lenses. Focus is very critical with these lenses, and it will take a dive or two in order to become comfortable with things like stabilizing, close focusing, and escaping sea life.

Telephoto lenses, longer than about 85mm, aren't much good underwater because of their limitation in focusing. Longer lenses are also more difficult to fit into a housing.

The faster your lens, the better it is for underwater photography. By fast, we mean it's widest f/stop opening is between f/1.4 and f/2.8. Lenses with openings of f/3.5 and smaller (the number itself gets larger), can be used with higher speed ISO films, if that's your only choice.

Film

Use ISO 400 negative print film for natural light underwater photos. This should give you plenty of latitude in most lighting conditions other than dark overcast skies. In clear tropical waters, especially under tropical sunshine, ISO 200 negative print film should work just fine in waters less than 15 feet deep. If you use an underwater flash system, ISO 100 and 200 should be the choice.

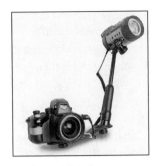

RS/SB 104 Nikon Underwater Camera

UW Camera Equipment EWA SLR Housing Plastic Bag

UW Camera Equipment Ikelite SLR Housing Plastic Housing

Exposure

Making the correct underwater exposure generally depends on the automatic system in your SLR or amphibious camera. When shooting with very wide angle lenses, auto cameras tend to read a bright background rather than a closer and darker subject. This means you must overexpose by about one f/stop. (Set your camera's exposure system on +1.) The same is true if your subject isn't well-lit from the surface.

Getting a good exposure procedure worked out requires shooting a few test rolls. We suggest doing this first in a swimming pool, then the open water. This testing is especially important when making underwater close-ups and flash photos.

We recommend an 81EF filter when shooting in clear tropical waters less than ten feet from the surface without a flash. This will replace some of the warmth, or red light, that is filtered out by the water. If the water appears blue to your eye, which it actually is, between 15 feet and the surface, we recommend using a CC-30-R. It is a little stronger correction filter.

Flash

Flash filling subjects, like other divers, shooting at about 1/3 of the unit's full power, will improve the definition and color of all subjects within about .ten feet. We suggest doing this with most of your underwater subjects. We also suggest taping a warming gel, about 81EF, to the front of your strobe. This will eliminate much of the blue created by the water. You will not need any filter on the camera's lens when using a flash to fill.

Light is very critical when shooting in deeper and darker water, or making extreme close-ups at any depth. Most of these shots are impossible without the use of an underwater strobe light. You will be amazed at the color a strobe brings out in small fish and pieces of coral. Underwater strobes should have automatic exposure capability, just like their surface counter parts.

Most water has some silt, debris, or other small particles floating around in it, even though it's not always visible to the eye. A strobe light mounted on, or near, your camera will illuminate and magnify these particles.

For this reason, your light should be held to the side or above your camera (using an extension cord) as far as possible. The better units have extension handles on them for this purpose.

Shooting Techniques

Shoot as close to your underwater subjects as is comfortably possible. Six to ten feet is good for most subjects. Wide angle underwater scenics don't make very good photos in most cases. When shooting underwater, swim in a slow and relaxed manner. Otherwise, you'll scare fish and bump into your subjects often because there aren't any brakes underwater. Sometimes two or three extra pounds on your weight belt will help keep you steady and slightly negative in buoyancy.

"SHOOT AS CLOSE TO YOUR UNDERWATER SUBJECTS AS POSSIBLE..."

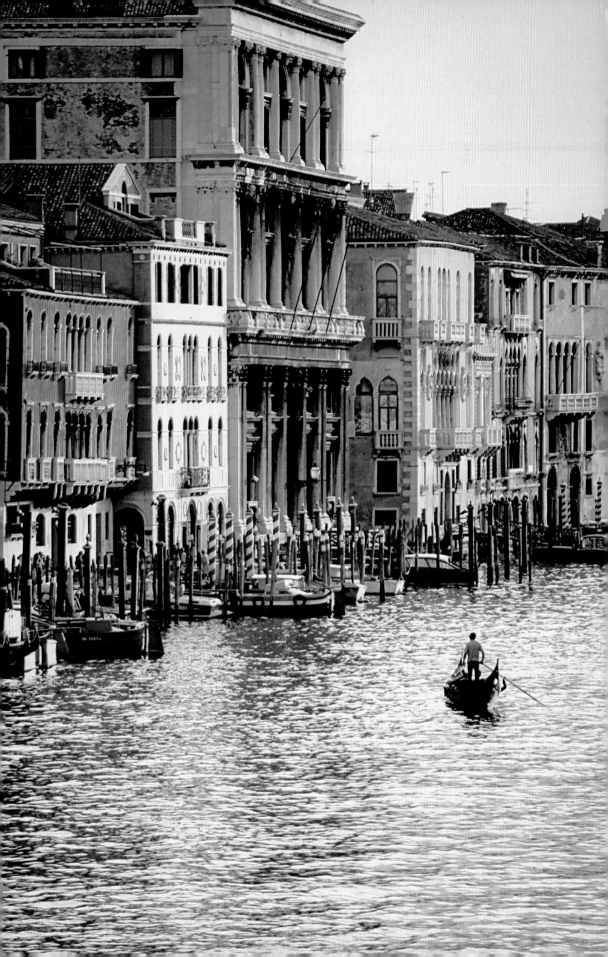

Above: *Recently painted umbrellas are seen drying in the afternoon sun, and photographed with the light coming through from behind. Film was over exposed by one f/stop. Chiang Mai, Thailand. Made with 85mm lens.*
Right: *An old weathered pier adds perspective and life to a blue Caribbean sky. Current Island, Bahamas. Made with 18mm lens and polarizer.*

Above: *A passing herd of camels makes an excellent storytelling silhouette. Sharjah Desert, United Arab Emirates. Sky is enhanced with an 85A filter. Made with 180mm lens.*
Below: *Contrary to popular belief, many Arab women will pose for photographs with advance permission of their husband, father, or brother. Casablanca, Morocco. Made with 85mm lens.*

Opposite page: *Theme parks are full of photo opportunities and color, like this killer whale show at Sea World. San Diego, California. A shutter speed of 1/250th of a second keeps a little motion in the shot.*
Above: *A Barong Dancer performs for the camera during an afternoon show. Bali, Indonesia. Made with 80-200mm zoom lens.*
Below: *Look for unusual angles, like this close-up of a totem pole face against the sky. Totem Bite Park, Ketchikan, Alaska. Made with 300mm lens.*

Top: *A professional swimsuit model makes this beach scene come alive with color and contrast. Palmilla Beach, San Jose del Cabo, Mexico. Made with 35-70mm zoom lens at 7am.*

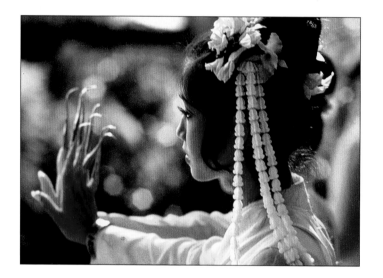

Middle: *A classical Siamese Dancer stands out against the background when photographed with a long telephoto lens in the open shade. Bangkok, Thailand. Made with 300mm lens.*

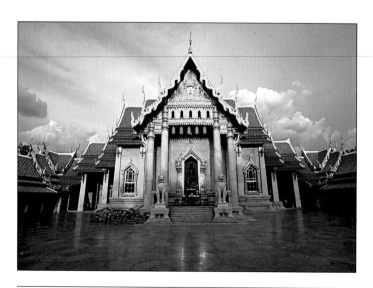

Bottom: *The late afternoon light brings the beautiful Wat Benchamabopit (just ask for the Marble Temple) to life for the camera. Like most popular tourist attractions, this courtyard is nearly full during the hottest daylight hours. However, it was deserted when we made this photo. Bangkok, Thailand. Made with 18mm lens and tripod.*

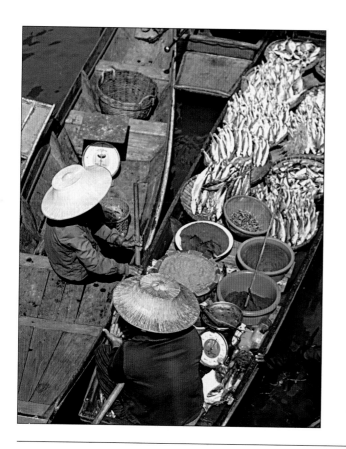

Above: A traditional Korean bride's hands, and the detailed embroidery of her dress, make an interesting medium close-up. Close shots like this can be easily made with a telephoto zoom lens. Folk Village, Seoul, Korea. Made with 80-200mm zoom lens.

Left: The Bangkok daily floating market is the place to get fresh fruit and interesting people pictures, especially with a long zoom lens. Damneun Saduak, Thailand. Made with 80-200mm zoom lens.

Following page: The Eiffel Tower, one of the most photographed landmarks in the world, is offset against a night sky with a 30 second time exposure. Paris, France. Made with a 28mm lens and tripod.

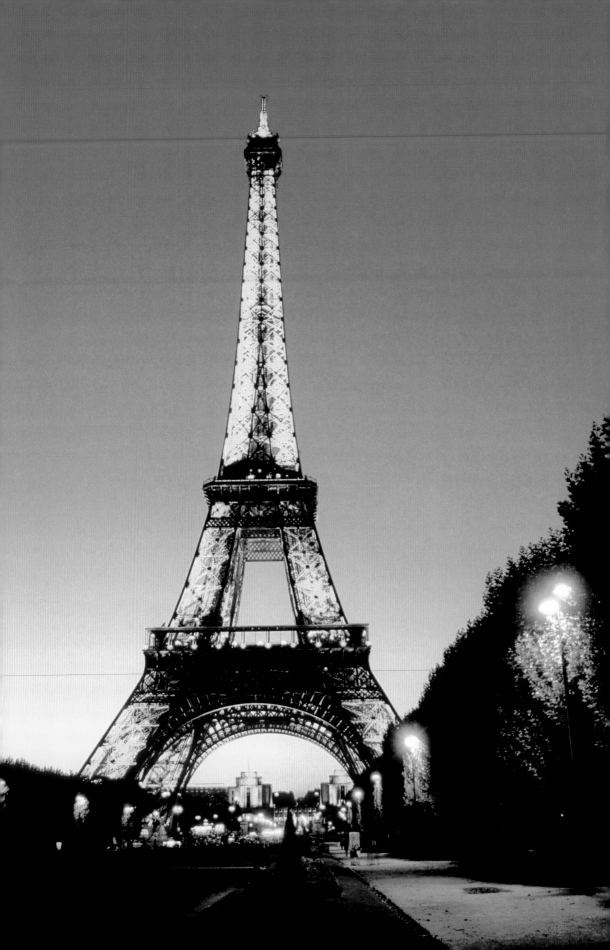

Practice shooting and directing people with hand signals in a pool first. Most divers find it hard to stay in one place, so you will have to move and shoot them along the way. Practice is important for making good underwater photos. So is experimentation. Try putting a snorkeler between you and the surface using the sun as a strong back light. Do the same with fish and coral heads. Take a little cheese to feed fish; it makes them very cooperative for photos.

Specialty Diving Tours

If underwater photography becomes one of your passions, we suggest taking specialty dive and travel tours. There are a number of companies that provide exciting package tours to the world's best photography and dive locations. (See magazines listed in the appendix.) For the most part, these tours provide everything you need in the way of transportation, accommodations, food, and equipment.

Caution

Resist the temptation to dive without the proper training and SCUBA certification. Never dive alone, or with a partner who isn't SCUBA certified. Your own safety depends on these rules. The more experienced and comfortable you are with SCUBA gear and diving, the safer your dives will be, and the better your underwater photos will look.

Notify your dive master, in advance of diving, of any physical limitations you may have, or any medical prescriptions you are taking. Alcohol and many prescription drugs do not mix well with SCUBA diving. If there are any questions or doubts about your physical ability to dive, or a medication, check with your doctor first.

Sharks, eels, rays, and big fish make excellent photo subjects. Some of them can also bite and seriously injure you. Coral reefs and other underwater sea life can also be dangerous to swimmers and divers. Find out what to watch for in the local area, and keep your eyes open. Much of this sea life is fragile and being destroyed by careless humans. Please don't be one of those people.

Winter Photography

When the temperatures drop and the snows come falling down, it's no reason to give up travel photography for the season. Subjects like skiing, ice skating, ice fishing, dog mushing, and interesting things that are covered by snow and ice, make beautiful travel pictures.

Temperatures

Temperature is everything in winter photography. The colder it gets and the longer you stay out, the more you must prepare for shooting conditions. Modern cameras function reasonably well at temperatures above zero, unless you spend an extended amount of time outside. However, when the mercury drops to Arctic temperatures of -20 and lower, cameras react the same as humans. They function slower than normal, act unpredictably, go to sleep, and freeze.

"CORAL REEFS...CAN ALSO BE DANGEROUS TO SWIMMERS AND DIVERS"

"STATIC CAN CREATE EXPOSURE STREAKS ON YOUR FILM..."

Humidity is also a problem when it gets really cold, causing static electricity. Static can create exposure streaks on your film if it's advanced too quickly. Cold film also becomes brittle and will break if advanced too fast. For these reasons, your film should be slowly advanced, manually if possible.

Arctic Temperatures

There are places in the world, such as the Arctic and Antarctica, where temperatures of -50 are commonplace. During winter months, locations above Alaska's Arctic Circle become a beautiful white desert that lends itself to incredible photography. The environment, however, can become hostile to the inexperienced and unprepared. A slight winter breeze in the city of Nome causes temperatures to hit -80 at times. If you're interested in shooting in such places, and they are winter wonderlands when the sun comes out, talk with people who live there before leaving home.

Equipment

There isn't much specialized photo equipment available for working in extremely cold conditions. Completely de-lubricated equipment, usually Lecia range finder cameras and lenses, is the choice of professionals. Having lubrication removed is expensive; the equipment can't be used for normal shooting, and it wears out quickly. There are warming and insulating devices available from photo equipment customizing people. These items are similar to the socks worn by hunters, in fact, frequent Arctic shooters often modify a pair of electric warming socks to cover their cameras.

Your standard equipment should work in cold conditions, so long as it isn't too old and full of dirt and grime that will freeze. Keep equipment inside your parka between shots where it will stay warm enough to work outside.

Do not force anything that has frozen or stopped, or you will have an expensive service charge. Things will probably improve after the camera has warmed up.

When returning to a warm area, after shooting in very cold temperatures, put your equipment into a plastic ziplock bag first, and then remove most of the air. This will allow condensation to form on the bag, instead of your equipment. In about half an hour, everything should be warm enough to remove it from the bag.

Film

Daylight film works just fine in cold conditions. Higher speed ISO films, 200 to 400, are usually needed because cold weather often means less light.

When shooting snow subjects in bright sunlight, ISO 100 film should be your choice. Keep all film inside your parka where it will stay warm before and after use. Leave it there for awhile after returning to a warm area.

Above: *A classic Eskimo is dressed in his winter fur parka. Arctic winters often bring temperatures of -50 degrees Fahrenheit. Kotzebue, Alaska. Made with 85mm lens.*
Right: *Normally a summer fishing camp, this cabin makes a nice winter photographer location. Alexander Creek, Alaska. Made with 35mm lens.*

Above: Temperatures rise to about 100 degrees Fahrenheit, with humidity near 100%, in these beautiful rice terraces. Bali, Indonesia. Made with 24mm lens.
Right: Sunrise is the time to shoot in desert locations such as these dunes. Temperatures can rise to 125 degrees Fahrenheit. Sahara Desert, Morocco. Made with 85mm lens.

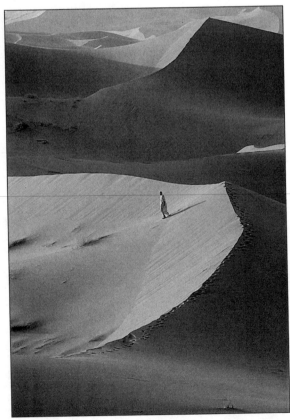

Exposure

Bright sunshine and snow often fool the exposure system in cameras, causing underexposed photos. You can correct this if the system has a fine point exposure selection mode to point close solid subjects. These systems are of no use in determining exposures of wide scenics. Otherwise, automatic exposure systems can be fooled by setting them on +1 for general bright scenes with dirty snow, and +2 for full sunshine and clean snow in sunshine conditions.

Flash fill should be used when shooting people in bright cold weather scenes, so long as they are less than ten feet from the camera. Do not put your camera on +1 or +2 exposure settings when using flash fill.

Caution

When outside temperatures drop below freezing, especially if accompanied by the slightest breeze, it can quickly become a dangerous situation for humans.

The lower the temperatures, the greater the danger of exposure and frostbite. In addition to freezing, your skin can stick to the surfaces of photo equipment and other frosty objects. Protect yourself from exposure by dressing for the weather. Ask in advance if you don't know the proper protective clothing to wear.

Never venture out into cold climates alone, or without advising others of your plans. Always have a warm destination, or stopover in mind. Go inside often and warm up. Eat hot soups. If you begin to loose the feeling in fingers, toes, or nose, go inside immediately and tell someone. In Arctic conditions, it's best to travel with a guide from the local area

Hot Weather Photography

Many of the world's most beautiful locations, beach and desert resorts included, enjoy high temperatures and high humidity for at least part of the year. If you're a traveler looking to save money on air transportation and accommodations, the off season (also called the hot season) can mean as much as 50% off the regular price.

No matter what the reason, if you're headed to a place with temperatures above 90 degrees Fahrenheit, nothing can adequately prepare your body.

Some people make visits to tanning salons, spend time in sauna baths, and get themselves physically fit in the local gym. All of these things will help ease that blast of heat experienced every time you leave the air-conditioned hotel. But they are just a starting place.

Immediately upon arrival in a warm location, try to acclimate yourself. Dress like the locals, in light-colored and light-weight outfits. Avoid air conditioning, if possible, using overhead fans to cool off instead. Stay out of the midday sunshine, and avoid alcohol, drinking lots of water instead.

Even with high morning temperatures, riding along in an airboat cools things off. This is also a fun way to see nature up close. The Everglades, Florida. Made with 24mm lens.

"NEVER VENTURE OUT INTO HEAT ABOVE 100 DEGREES ALONE..."

Never venture out into heat above 100 degrees alone, or without advising others of your plans. Go inside often to cool off with a cold drink. If you begin to turn red, or feel the heat rising in your head, go into a cool place immediately and tell someone.

Equipment & Film

Your standard camera equipment and film should work just fine in most hot climates. If you plan to travel in heavy tropical jungles, some sort of plastic baggy cover should be placed around your shooting camera. Place another around equipment and film in your shoulder bag. This should help eliminate most of the moisture.

Exposure

If you shoot early in the morning and late in the afternoon, both the temperatures and light should be cooperative. Making your exposures in warm climates is pretty much the same as with normal temperatures. Keep an eye on your human subjects to make sure they don't look half dead from the heat. Also be sure their clothing isn't soaked.

Caution

High temperatures, humidity, and blazing direct sun can drain the human body within minutes, causing heat stroke, sun stroke, and exhaustion. Space your shooting sessions out, scheduling cooling off breaks at least once an hour, more often if you are fair-skinned, or overly sensitive to tropical conditions. Travel with a local guide who understands that high temperatures are new to you.

Close-up Photography

We know that close-up photography isn't exactly an extraordinary environment, but it can acquaint you with an interesting world of shooting that many photographers ignore.

In talking about close-up or macro photography, we mean subjects like stamps, coins, flowers, and other things that can be held with your hands or fingers. Photographing things that are too small for the human eye to see falls into the specialized area of micro photography.

Equipment

Most of today's medium range zoom lenses, between 35mm and 200mm, have a close-up or macro photography setting. Some telephoto lenses, between 85mm and 200mm, can focus close, and will also cover smaller subjects well.

There are specialty *macro focus* lenses, that are made for small subjects; some have a series of extender attachments which allow you to move in even closer. Some of these extenders are available for regular lenses too. We suggest using them on lenses between 80mm and 135mm.

Focus is critical in close-up photography. We suggest using a tripod to prevent camera movement and fuzzy pictures.

MACRO LENS

A lens that allows the photographing of small objects, such as stamps and coins, at their actual life size.

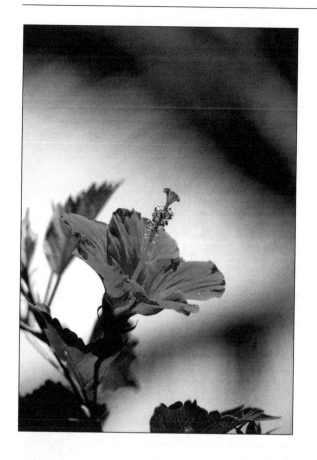

Left: *Flowers are a beautiful subject for close-up photography. This is a medium shot of a Hibiscus flower. Luzon Island, Philippines. Made with a 55mm macro lens, flash fill, and tripod.*
Below: *A telephoto lens allows easy shooting of this Monarch Butterfly. Yakima, Washington. Made with a 180mm lens that will focus down to about seven feet.*

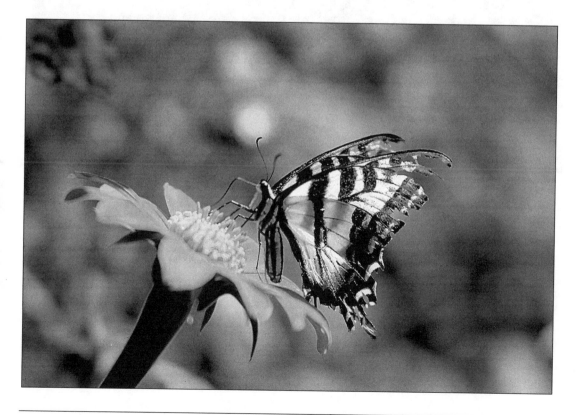

Above: *A zoom lens with Macro setting allows a tight and sharp focus close-up of wild orchids, while the background turns soft. Big Island, Hawaii. Made with 35-70mm zoom, with flash fill.*
Below: *Hakata Doll Maker putting the finishing touches on a tiny porcelain face.Fukuoka, Kyushu Island, Japan. Made with 85mm lens, flash fill, and reflector, using ASA 400 film.*

Film

Your standard daylight film should work just fine when shooting close-up subjects. Higher ISO films, with speeds of 200 to 400, will provide more depth and allow faster shutter speeds. This will also help keep pictures sharp on difficult subjects.

Exposure

With the exception of specialty macro focus lenses, most lenses and auto camera systems take care of their own settings when shooting close-up subjects. If yours doesn't, make a few test shots. Items that appear life size in your viewfinder generally require twice as much exposure. Follow the manual when shooting with a specialty macro lens.

Flash Fill

A little flash fill will add color and sharpness to many close subjects, especially flowers and similar semi-transparent subjects. *Strobe* flashes that are mounted on your camera will not work for most small subjects. Visit the photo store and get an extension adapter cord which will allow you to hold the flash away from the camera. Try side, front, and back lighting flowers for some bright and colorful shots.

STROBE

An electronic flash unit that its powered by batteries or AC plug.

Electronic flashes range from small on camera units to large stand-mounted lights.

Camera Care

If you shoot frequently in different environments, especially those with extreme ranges of temperature and humidity, or air that is filled with salt water or dust, your equipment will suffer. This is a constant problem for professional travel photographers which causes them to replace their equipment on a regular basis.

Keep your equipment as clean and dry as possible. Constantly inspect all surfaces, inside and out, for dust, dirt, and moisture. Carry a small bottle of lens cleaner, some soft tissue, and a soft hair brush which should be used to clean all surfaces. If you're headed to dusty areas, carry along a small can of cleaning air, available from the photo store.

If you drop a camera in the water, or have an underwater housing flood, immediately dunk your camera in fresh water for a few seconds (if you dropped it in sea water), and head to a camera repair shop. If you can't get it to a repair shop within a few hours, hold the camera a few inches from your face, and kiss it good-bye.

Notes

Keep detailed notes on everything. Record the conditions and light, the type of film, subjects, and the equipment you use in extraordinary environments. Learn from your successful shots and mistakes. We suggest reserving a special section in your trip book for this purpose. Remove it when you get home and put it into your permanent shooting record notebook. Over the years, this information will save you a lot of time and headaches.

A Final Caution

Making photos from the air, underwater, in cold climates, and in hot climates, often involves hazardous elements and situations. The information we have provided here is meant to acquaint you with these exciting aspects of travel photography. They will not make you an expert. There are several publications and workshops available on these subjects which are recommended to help you gain the necessary experience to safely make photos in these environments.

We also suggest taking basic courses in First Aid, Swimming, Life Saving, Map and Compass Reading, and All-Weather Survival. Military and surplus shops have excellent field manuals available on these important subjects.

Shooting against a hot sun, on one of the world's whitest beaches, is the place to bracket exposures. The best setting was overexposed 1.5 f/stops. Seaside, Gulf Coast, Florida. Made with 24mm lens.

Chapter 8

WHAT TO DO WITH YOUR PHOTOS

"GIVE YOUR PHOTOGRAPHS THE CARE AND STORAGE THEY DESERVE."

Sooner or later travel and photography will become an important part of your lifestyle. It probably already is, if you're taking the time to read this book. You will become known for the photos you show, not for the number of shots you make in some distant location. Showing off beautiful photographs allows you to enjoy trips again and again, as does sharing your best work with friends and family.

Care & Storage

When your prints and negatives are back from the processing lab, remember how much work and expense it has taken to reach this stage. Keep in mind that today's pictures will be tomorrow's priceless memories. Give your photographs the care and storage they deserve.

Negatives and slides should be sleeved, identified, and stored in clean, dry, and cool file cabinets. This is an example of a photo library storage system.

Keep all of your original negatives, or slides, in protective sheets. That's usually the way they come from processing. Immediately mark these sheets with the location, subjects, and date made using plain white stick-on labels. Store these protective sheets by location, or subject, in folders and some type of file cabinet. Some photographers get two small prints for each shot, at the initial time of processing. One is their show off, or giveaway print, the other is for file and subject identification records, with information marked on the back.

Stamp or write your name and address on every negative sheet, also using plain white stick-on labels. This will make it easy to identify shots that go astray in processing and printing. Make sure your negative file is in a cool and dry place that's locked. Immediately mark your "great" shots, holding one of the prints aside. These are the shots that should be used for displays and other shows.

Digital Storage

The magic of computers makes it possible to store your best images on special Photo CD Disks. They can be shown on a television screen, like a slide show, manipulated with special software, and even printed out. With some programs and communications networks, you can send samples of your photos out to friends who are also "on-line" with similar systems. This is an excellent way to make new traveling friends and research future shooting locations.

Home & Office Display

Your best work should be enlarged and on display at home and in your office space. Update these display prints after every shooting trip.

The best prints come from custom labs, and are made on high gloss paper. Have a few samples made before selecting a lab. Have your prints mounted and framed, just like the professionals, and remember the photo should be enhanced by it's framing and display location, not act as a distraction.

Public Displays

If your display prints are good, sooner or later someone will ask why your work isn't on public display. There are many places that would love to show, and sell for commission, good travel photos made by their best customers. Ethnic restaurants, frame shops, camera stores, book stores, coffee shops, banks, travel agencies, CPA's, doctors and other small businesses, are excellent places to approach regarding possible displays. If your work goes over well in shows at small businesses, it's sure to do well in schools, churches, retirement homes, and galleries.

When you do any showing of photos, the images should flow around some type of theme. This might be a location, city, park, industry, ethnic culture, event, or something in which you have a special interest. Have a little party to announce the show, and be sure to invite the local newspapers. Show a few of your very best shots. Bigger is

"YOUR BEST WORK SHOULD BE ENLARGED AND ON DISPLAY..."

Show off your best photos at home or in the office by framing large prints. This is the reception area of our office.

generally better with display prints. Have them mounted for display, using half-inch foam core mounts. They are excellent for this purpose. Display prints also need good lighting, preferably small wattage spotlights for each shot.

Contests

Camera stores, camera clubs, county fairs, travel agents, airlines, magazines, societies, and other public organizations often have photo contests. This is a fun way to show your work, and see the images of other photographers. They are especially fun if you win something.

Make sure the rules and entry forms, which must be signed, do not give away the copyrights to your pictures. These contests do need the right to publicize their winners, but they should also be required to pay

for any advertising uses. A word about winning photo contests: Different judges see different things in different photos. What this means is you may or may not win a contest. Just by entering you're already a winner because you have the courage to place pictures up against the best other photographers have to offer. If you're serious about winning, try to get a look at the photos which have won previous year's contests and make sure to equal their quality and look. Follow their printed rules to the letter.

Photo Parties

In the end, you've traveled around and made some fun and interesting photos. Have the best images made into slides, at your local lab, or scanned onto a photo CD. Invite your friends over for some great food and drinks, and a showing of your latest adventure. Show no more than 100 images total, perhaps accompanied by your comments and a little matching ethnic music. Leave them begging for more and thinking you're a great photographer.

> **"IN THE END, YOU'VE TRAVELED AROUND AND MADE SOME FUN AND INTERESTING PHOTOS."**

Photography should capture the fun of life, like this shot of fishing excitement. Gulf Coast, Florida. Made with 28mm lens and flash fill.

The Beginning

By now you know that we think traveling and photography should be interesting, fulfilling, and most important, fun. It should also be the beginning of a wonderful adventure through life and the world. As you travel along, trying to remember all the things we suggest in this book, remember to get some enjoyment from the journey too.

APPENDIX A

Further Reading and Information Resources

Planning and researching are the most important first steps towards successful travel and photography. There are hundreds of wonderful books, magazines and information resources available to help with your images and travels. Most of the travel-oriented magazines also offer listings of excellent tours for people with cameras. It would be impossible to list everything that's available, so we're mentioning a few of our favorites in this appendix. All of these references feature the best in photography.

Photography Books

Big Bucks Selling Your Photography
Cliff Hollenbeck
Amherst Media
Box 586
Amherst NY 14226
(716) 874-4450 Fax (716) 874-4508

Modesty does not prevent us from recommending this book on the business of freelance of photography. It covers everything, including: creativity, administration, computerization, business plans, photography and the law, taxes, selling, portfolios, business forms, and stock files. It's one of the best resources for any independent business.

The Photographers
Leah Bendavid-Val
National Geographic Books
(800) 647-5463

This book should have been called "The Best Of National Geographic Photography." The images in this book are among the best of travel related subjects ever made. Sadly, there's very little about the photographers, or how the images were made. Despite this omission, the book is an excellent resource that will provide hours of enjoyable armchair traveling and ideas for future trips.

Travel Photography

Susan McCartney
Allworth Press
10 East 23rd. Street
New York, NY 10010
(716) 874-4450 Fax (716) 874-4508

This is one of the most complete guides on the art and business of travel photography. Susan McCartney has traveled throughout the world to photograph a wide variety of people and their cultures. If you have any aspirations toward selling travel photos, her book will be an invaluable resource.

Guide to Photographing California

Amherst Media
Box 586
Amherst NY 14226
(716) 874-4450 Fax (716) 874-4508

Florida: Guide to Nature and Photography

Cumberland Valley Press
1216 Vintage Place
Nashville, TN 37215

A Guide to Photography and the Smokey Mountains

Cumberland Valley Press
1216 Vintage Place
Nashville, TN 37215

If you're planning a photo trip to one of these photogenic locations, we suggest reading the appropriate Photo Guide book first. They are full of extensive activity and event information, maps, shooting locations, shooting tips, weather and climate conditions, and, of course, high quality photography.

The Wildlife Photographer's Field Guide

Joe MacDonald
Amherst Media
Box 56
Amherst NY 14226
(716) 874-4450 Fax (716) 874-4508

One of the best wildlife photographer's references and technical guides. Tips on equipment, lighting, and film for shooting wildlife. Also includes some interesting suggestions for macro, aquarium, and studio animal photography.

Guide to Photographing Underwater Wonders

Rick Sammon
Voyageur Press, Inc.
123 North 2nd Street
P.O. Box 338
Stillwater, MN 55082

This is a complete guide and resource for beginning and experienced underwater photographers. Full of technical and artistic information, as well as excellent examples of what you can shoot with a little practice

The Traveling Photographer

Ann and Carl Purcell
Amphoto
1515 Broadway
New York NY 10036

This is a well written and photographed guide to the world of shooting beautiful travel photos. The Purcells are a respected team who have provided hundreds of excellent ideas, suggestions and samples for the traveler interested in making pictures. Their images of interesting and exotic people, from throughout the world, is an inspiration to all photographers.

National Geographic World Atlas

NGS Society: (800) 647-5463

Every traveler should have an extensive world atlas, if only to know where they are going and what's in the immediate area. The NGS Atlas is one of the best, featuring physical maps, covering continents, regions, nations, transportation networks, cultural and historical sites, and oceans, with an extensive index. They also publish an exciting CD-ROM multi-media Picture Atlas of the World. In addition to their extensive physical maps and related information, you can watch videos, see still photos, hear music, hear languages and a host of statistics about many places in the world, all through an interactive self-guided system. Sadly, this wonderful program is just a sampler and doesn't show many photos from each country.

Photography Magazines

Nikon World
Quarterly
Subscription Information: (515) 486-4200

A beautiful magazine which features the best contemporary photography and photographers in the world. How-to articles, new product information, and exciting portfolios are featured in each edition. A free short-term subscription comes with the purchase of some Nikon equipment.

Popular Photography
Monthly
Subscription Information: (800) 876-6636

The largest circulation magazine covering general interest still and video photography subjects. Hundreds of articles every year on new equipment, shooting ideas, films, photographers, and related subjects. Their advertising section is also an excellent resource for pricing and purchasing new equipment.

Outdoor Photographer
Monthly
Subscription Information: (800) 283-4410

This is a beautiful travel photographer's magazine. Every issue has high quality articles and pictures, by noted photographers, destination reviews, plus a selection of interesting location workshops and seminars.

Petersen's Photographic
Monthly
Subscription Information: (800) 800-3686

A very good general interest photography magazine. Articles cover equipment, unusual shooting, location information, and similar subjects ranging from amateur to professional. A good resource for comparison testing of new equipment and films.

The Professional Photographer
Monthly
Subscription Information: (800) 786-6277

Publishes a great deal of educational information, and examples of their member's work, all aimed at helping photographers improve their art and businesses. Free to members of Professional Photographers of America.

Photo District News
Monthly
Subscription Information: (800) 745-8922

If you're interested in the business of photography, this magazine is a must. PDN independently covers all the current rights, rates, and advances in professional photography. It has yearly special issues on photo specialties, including features of the best images of the world's leading photographers.

Travel Magazines

National Geographic Traveler
Monthly
Subscription Information: (800) 647-5463

The best all-around travel information and photography resource available. In addition to interesting articles and colorful photos, specific travel information is provided for each location mentioned in the magazine. We maintain a complete library of this magazine, and use them as our first information source when planning to shoot a new location. They have a good reader resource service for the areas the magazine has covered in past issues.

Condé Nast Traveler
Monthly
Subscription Information: (800) 777-0700

Contains a wide variety of detailed travel and feature-related information. Some of their photography is incredible, although many of their covers fall under the heading of "interesting." A call to their Traveler's Hot Line, (800) WORLD24, will get you a Traveler Index and, for a small fee, reprints of specific articles. This service alone can save you hours of research time, and is worth the price of a subscription.

Islands
Bi-Monthly
Subscription Information: (800) 284-7958

Reading this magazine creates a desire to see the world's most dazzling and interesting islands. It's one of the best written, photographed, and edited travel magazines. A very good resource for location information, accommodations, and tours.

Caribbean Travel & Life
Bi-Monthly
Subscription Information: (301) 588-2300

The perfect magazine and travel planning resource, if you're interested in the Caribbean. Nice photography and travel articles on this gorgeous part of the world. Has an excellent villa rental guide and readers information service.

Florida Travel
Quarterly
Subscription Information: (301) 588-2300

This is a relatively new magazine, brought to you by the same people who publish Caribbean Travel and Life Magazine. The early issues show it to be a good resource for traveling in a state that lends itself to great and easily accessible travel photography.

Islands of Aloha
Bi-Monthly
Subscription Information: (808) 593-1191

This is the Official Guide of the Hawaii Visitor's Bureau. It's one of the most complete travel resources available; certainly the best travel planner for those wonderful islands. Full of nice travel photography.

Outside
Monthly
Subscription Information: (800) 678-1131

Aimed at "off the beaten path travelers," this magazines provides great exercise-oriented, adventure, and environmental travelers' information, including good trip-finder guides.

Historic Traveler
Bi-Monthly
Subscription Information: (800) 435-9610

If you're a history buff, or not, this is a high quality guide to the world's celebrated historic destinations. Full of information, travel ideas, and quality photography that will help lead you to many adventures.

Country Inns
Bi-Monthly
Subscription Information: (800) 877-5491

An excellent travel resource. Full of information on the world's leading bed and breakfast country inns. Very good photography and articles on some interesting places to stay and shoot.

Skin Diver
Monthly
Subscription Information: (800) 800-3487

Long the underwater world's leading publication, it's full of good technical editorial information, beautiful photography, and related advertising. Published by the people at Petersen's Photographic Magazine.

Dive Travel
Quarterly
Subscription Information: (800) 833-0159

Devoted strictly to international traveling divers, this magazine is a very good information resource. It's full of quality photography and tourism resources.

Information Resources

The National Geographic Society
17th & M Streets
Washington DC 20036
(800) 647-5463

The National Geographic Society is the grandfather of travel and photography, and publications relating to these subjects. Materials available from the NGS include magazines, books, maps, videos, and similar items. A membership in the Society includes a subscription to the National Geographic Magazine, which has always been considered the leader in destination photography, and helps provide funds to many international causes and expeditions. Non-members, as well as members, can request a catalog of their many publications by phone.

American Automobile Association (AAA)
National Information Number: (800) JOIN-AAA

The AAA is probably the most complete travel information and service organization in business. A few of the many membership benefits include: Nationwide 24 hour a day emergency Road Service; complete personalized trip planning (with routes plotted on very detailed maps); a complete travel agency (they offer free traveler's checks, international driver's licenses; an Insurance Agency (cars, boats, RV's, personal property, etc.), and a host of related travel information and publications.

Barron's Language Packages
113 Crossways Park Drive
Woodbury NY 11797
(516) 434-3311

Barron's produces some of the best foreign language study packages available. Their language survival kit for travelers contains a phrase handbook-dictionary, 90 minute cassette tape with pocket size transcript, a calculator, a travel diary with local maps and a pen—all for under $20. They have several different programs and languages available including, Japanese, German, Spanish, Italian, French, Chinese, Greek, and Portuguese.

Professional Photographers of America (P.P. of A.)

Membership Information: (800) 786-6277

This organization is dedicated to photographers in all their many specialties. They have chapters throughout the world who offer workshops, seminars, and salon displays of their member's best work. This is an excellent organization for professionals and serious amateurs. Many of their programs are available to non-members.

GLOSSARY

APERTURE - The adjustable opening of a lens which controls the amount of light that reaches the film. The size of the opening is called an f/stop.

ASA - American Standards Association. The organization which, in the past, set the light sensitivity rating for photographic films. ISO, the International Standards Organization, has replaced most of the ASA ratings. They generally mean the same sensitivity. Either set of letters generally appears before a number, such as ISO 100 or ASA 100.

AUTOMATIC CAMERA - Generally refers to a camera that automatically determines exposure, focus, and flash requirements for the photographer. The better cameras also allow manual override operation.

AVAILABLE LIGHT - The natural, or existing, light in a scene.

BRACKETING - Making exposures over and under the camera or light meter's setting, after an exposure has been made at the suggested setting. Bracketing insures that a correct exposure is made in situations such as in very bright snow, or at night that may fool the meter.

CAMERA SYSTEM - A related system of camera, lenses, flash, and accessories, that are all produced by the same manufacturer. Systems generally guarantee that everything works together. This is important with totally automatic cameras.

CLIP TEST - Processing the first few inches of a roll of film to determine if the exposure is correct. Processing time can be changed, after examining the clip test, to correct improper exposures. Available from professional custom labs.

CONSULATE - An office representing a foreign country where a fully staffed Embassy isn't practical. Most consulates issue visitors' visas, provide tourism information, and other business information for their country. The same services are also provided by an Embassy.

CONTRAST - The difference between bright highlights and shadow areas of a scene. Also, the difference between hot and subdued colors.

DIVE MASTER - A person who has been tested and certified by a professional SCUBA diving organization to plan and lead underwater excursions and, in most cases, instruct diving-related activities. Diving with a Dive Master is an excellent idea for inexperienced divers and snorkelers, especially in unknown locations.

ELECTRONIC FLASH - A flash unit that is powered by batteries, or AC plug. Electronic flashes range from small on camera units to large stand mounted lights. Also called a strobe light.

EMBASSY - The main diplomatic office representing a foreign country. Handles tourism and business travelers, imports and exports, and related business between their home country and the local country. Issues visitors visas and provides tourism information. Similar services are provided by a Consulate.

EXPOSURE LATITUDE - The range of exposure a film will take and still produce an acceptable image. For example, print film can be under or overexposed about one and one-half f/stops and still look good. Most slide films have a exposure latitude of less than one-half f/stop over or under.

EXTENDERS - A device that attaches between your camera and lens, which doubles the focal length of the lens. A 100mm lens becomes a 200mm lens. Extenders, also called doublers, allow closer focusing when shooting such things as flowers.

F/STOP - The adjustable opening of a lens, which controls the amount of light that reaches the film, is called aperture. The size of that opening is called an f/stop.

FAST FILM - Film with an ISO rating of 400 and above, is considered to be "fast". Across the counter fast films are available up to ISO 1600. Custom processing labs can push process ISO 400 as high as ISO 1600. High ISO films allow exposures in low-level natural light situations.

FAST LENS - A lens with an aperture, f/stop, opening larger than f/2, is considered to be fast. The fastest lenses are generally f/1.4 and f/1.2. These lenses allow exposures in low-level natural light situations.

FILL LIGHT - Flash or reflector light used to brighten, or fill, shadows, such as those on a face caused by a hat. An especially useful tool when shooting in bright sunlight.

FOCAL LENGTH - The distance from the film to the optical center of a lens. Usually expressed in millimeters. For example, a normal lens is a 50mm.

HEALTH CERTIFICATE - Similar to a passport, a Health Certificate lists the inoculations a person has received. Most medical doctors and health clinics can give shots that are required by foreign governments for entry into their country. This information is available at any passport office.

ISO - International Standards Organization, which sets the light sensitivity rating for photographic films. The ISO rating has replaced most of the older ASA American Standards Association ratings. Either set of letters generally appear before a number, such as ISO 100 or ASA 100.

MACRO LENS - A lens that allow photographing small objects, such as stamps and coins, at their actual life size.

NORMAL LENS - A lens that sees approximately the same as the human eye. When using a 35mm SLR camera, the normal lens is a 50mm.

PASSPORT - A document, generally a booklet, that is used as personal identification when traveling between countries. The U.S. Passport is probably the best-known form of identification in the world.

PHOTO CD - A computer disk that accepts photographic images for viewing or manipulation. Similar to a CD-ROM, which is a disk that can contain photography, software, various programs such as an Atlas of the World.

PUSH PROCESS - When a custom processing lab increases the ISO of film because it has been exposed in lower level light situations. The entire roll must be exposed at the same ISO setting. For example, ISO 400 film can be push processed as high as ISO 1600.

REFLECTOR - Any device that reflects a light source onto a subject. This reflected light may be used as the only source of light, or to fill the shadows of other light sources. There are several different types of reflectors available at camera stores, although a simple piece of white cardboard will also do the job.

SCUBA - Self Contained Underwater Breathing Apparatus, which generally means the tanks and breathing regulator used by a diver to breath underwater. Thus the term, "SCUBA Diver."

SHUTTER SPEED - The length of time the shutter is open exposing the film in a camera. A shutter speed of about 1/250th of a second is necessary to get a sharper picture of some walking, 1/500th for someone jogging.

SILHOUETTE - The dark shadow-like outline of something photographed against a light source.

SLR - Single Lens Reflex. The common 35mm camera that allows viewing through the lens, and seeing what the film does at the moment of exposure.

STROBE - An electronic flash unit that is powered by batteries, or AC plug. Electronic flashes range from small on-camera units, to large stand-mounted lights.

SURVIVAL LANGUAGE - A list of foreign words and phrases, and their translation, used by travelers to "survive" getting around in another country.

TELEPHOTO LENS - A lens that magnifies a scene larger than normal. Lenses longer than about 70mm are considered telephoto. A 500mm lens is considered a long telephoto.

TRANSPARENCY - What professional photographers call a slide that is larger than 35mm.

TRIP NOTEBOOK - A three-ring binder that contains everything connected with your trip. It should go with you on the trip. It might include such things as schedules, maps, articles, letters of introduction, and so on.

VISA - Permission, generally in the form of a signed stamp in a passport, given to enter a foreign country by that country.

WIDE-ANGLE LENS - A lens that photographs more than a normal lens. These lenses spread subjects out in length and width by increasing the field of view and expanding the image. Lenses shorter than 35mm are considered wide-angle — a 20mm is a very wide-angle lens.

INDEX

Other Books from Amherst Media

Basic 35mm Photo Guide
Craig Alesse

Great for beginning photographers! Designed to teach 35mm basics step-by-step — completely illustrated. Features the latest cameras. Includes: 35mm automatic and semi-automatic cameras, camera handling, f-stops, shutter speeds, and more! $12.95 list, 9 x 8, 112 p, 178 photos, order no. 1051.

Big Bucks Selling Your Photography
Cliff Hollenbeck

A strategy to make big bucks selling photos! West Coast photographer Cliff Hollenbeck teaches his successful photo business plan! Features setting financial, marketing and creative goals. This book will help to organize business planning, bookkeeping, and taxes. $15.95 list, 6x9, 336 p, Hollenbeck, order no. 1177.

Infrared Photography Handbook
Laurie White

Totally covers infrared photography: focus, lenses, film loading, film speed rating, heat sensitivity, batch testing, paper stocks, and filters. Black & white photos illustrate how IR film reacts in portrait, landscape, and architectural photography. $24.95 list, 8 1/2 x 11, 104 p, 50 B&W photos, charts & diagrams, order no. 1383.

Camera Maintenance & Repair
Thomas Tomosy

A step-by-step, fully illustrated guide by a master camera repair technician. Sections include: testing camera functions, general maintenance, basic tools needed and where to get them, basic repairs for accessories, camera electronics, plus "quick tips" for maintenance and more! $24.95 list, 8 1/2 x 11, 176 p, order no. 1158.

Wedding Photographer's Handbook
Robert and Sheila Hurth

The complete step-by-step guide to photographing weddings – everything you need to start and succeed in the exciting and profitable world of wedding photography. Packed with shooting tips, equipment lists, must-get photo lists, business strategies, and much more! $24.95 list, 8 1/2 x 11, 176 p, index, b&w and color photos, diagrams, order no. 1485.

McBroom's Camera Bluebook
Mike McBroom

Comprehensive, fully illustrated, with price information on: 35mm cameras, medium & large format cameras, exposure meters, strobes and accessories. Pricing info based on equipment condition. A must for any camera buyer, dealer, or collector! $24.95 list, 8x11, 224 p, 75+ photos, order no. 1263.

Wide-Angle Lens Photography
Joseph Paduano

For everyone with a wide-angle lens or people who want one! Includes taking exciting travel photos, creating wild special effects, using distortion for powerful images, and much more! Part of the Amherst Media's Photo-Imaging Series. $15.95 list, 7 x 10, 112 p, glossary, index, appendices, b&w and color photos, order no. 1480.

Zoom Lens Photography
Raymond Bial

Get to know the most versatile lens in the world! Includes how to take vacation, landscape, still life, sports and other photos. Features product information, accessories, shooting tips, and more! Part of the Amherst Media's Photo-Imaging Series. $15.95 list, 7 x 10, 112 p, b&w and color photos, index, glossary, appendices, order no. 1493.

Great Travel Photography
Cliff and Nancy Hollenbeck

Cliff Hollenbeck was twice named Travel Photographer of the Year – so learn how to capture great travel photos from a pro! Part of the Amherst Media's Photo-Imaging Series. $15.95 list, 7 x 10, 112 p, b&w and color photos, index, glossary, appendices, order no. 1494.

The Art of Infrared Photography
Joseph Paduano

A complete, fully illustrated approach to B&W infrared photography for beginners and professionals. Features: filter use, film speed, exposure, and much more! $17.95 list, 9 x 9, 76 p, 50 duotone prints, order no. 1052.

Build Your Own Home Darkroom
Lista Duren & Will McDonald

This classic book shows how to build a high quality, inexpensive darkroom in your basement, spare room, or almost anywhere. Information on: darkroom design, woodworking, tools, and more! $17.95 list, 8 1/2 x 11, 160 p, order no. 1092.

Into Your Darkroom/ Step-by-Step
Dennis P. Curtin

The ideal beginning darkroom guide. Easy to follow and fully illustrated each step of the way. Information on: equipment you'll need, set-up, making proof sheets and much more! $17.95 list, 8 1/2 x 11, 90 p, hundreds of photos, order no. 1093.

The Freelance Photographer's Handbook
Fredrik D. Bodin

A complete handbook for the working freelancer. Full of how-to info & examples. Includes: marketing, customer relations, inventory systems, portfolios, and much more! $19.95 list, 8 x 11, 160 p, order no. 1075.

The Wildlife Photographer's Field Manual
Joe McDonald

The complete reference for every wildlife photographer. A complete technical guide, including info on: lenses, lighting, field exposure, focusing techniques, and more! $14.95 list, 6 x 9, 200 p, order no. 1005.

Underwater Videographer's Handbook
Lynn Laymon

Have fun shooting your own underwater videos! Fully illustrated and packed with step-by-step instructions on basic & advanced techniques, video dive planning, underwater composition, and much more! $19.95 list, 8 1/2 x 11, 128 p, over 100 photos, order no. 1266.

More Books Are Available!

Write or fax for a *FREE* catalog:
AMHERST MEDIA, INC.
PO Box 586
Amherst, NY 14226 USA

Fax: 716-874-4508

Ordering & Sales Information:

Individuals: If possible, purchase books from an Amherst Media retailer. Write to us for the dealer nearest you. To order direct, send a check or money order with a note listing the books you want and your shipping address. U.S. & overseas freight charges are $3.00 first book and $1.00 for each additional book. Visa and Master Card accepted. New York state residents add 8% sales tax.

Dealers, distributors & colleges: Write, call or fax to place orders. For price information, contact Amherst Media or an Amherst Media sales representative. Net 30 days.

All prices, publication dates, and specifications are subject to change without notice.

Prices are in U.S. dollars. Payment in U.S. funds only.

Amherst Media's Customer Registration Form

Please fill out this sheet and send or fax to receive free information about future publications from Amherst Media.

CUSTOMER INFORMATION

DATE

NAME

STREET OR BOX #

CITY STATE

ZIP CODE

PHONE ()

OPTIONAL INFORMATION

I BOUGHT *GREAT TRAVEL PHOTOGRAPHY* BECAUSE

I FOUND THESE CHAPTERS TO BE MOST USEFUL

I PURCHASED THE BOOK FROM

CITY STATE

I WOULD LIKE TO SEE MORE BOOKS ABOUT

I PURCHASE BOOKS PER YEAR

ADDITIONAL COMMENTS

CUT ALONG DOTTED LINE

FAX to: 1-800-622-3298

IF MAILING, FOLD IN NUMBER ORDER ALONG DASHED LINES.

①

②

Name_____

Address_____

City_____State_____

Zip_____ — _____

Place
Postage
Here

Amherst Media, Inc.
PO Box 586
Amherst, NY 14226

③

IF MAILING, PASTE UNDERSIDE OF FLAP, OR TAPE HERE.